inside acrylics

insideacrylics
studio secrets *from today's top artists*

phil **garrett**

NORTH LIGHT BOOKS
CINCINNATI, OHIO
www.artistsnetwork.com

Contents

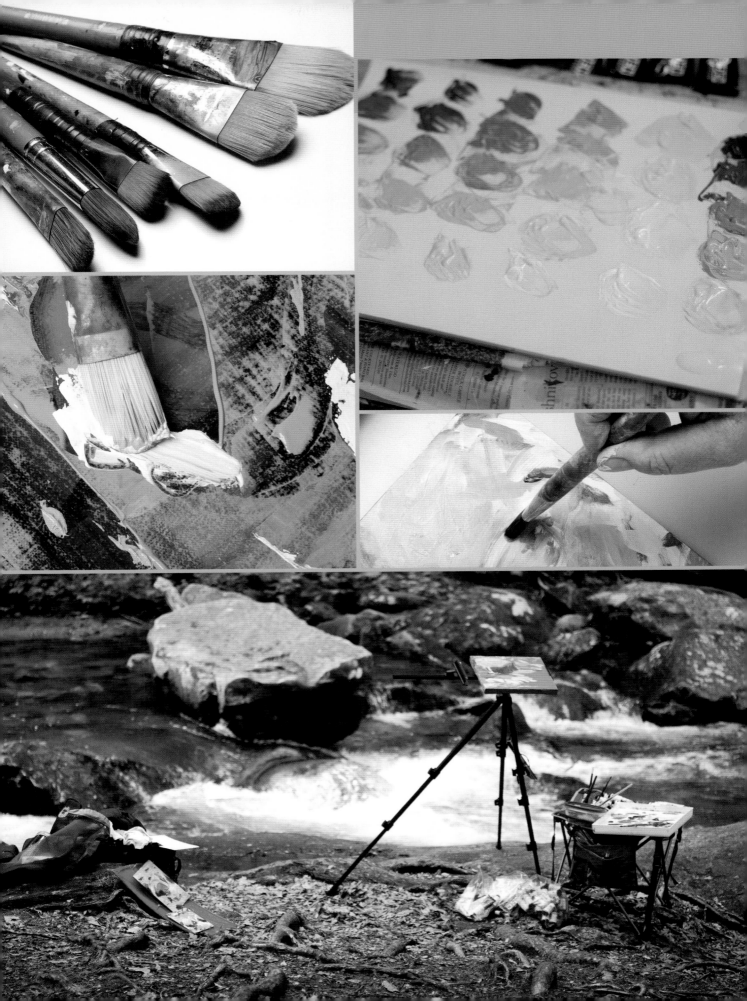

introduction

T his book is a guide for painters of all skill levels seeking a comprehensive and user-friendly approach to working with acrylic paints and their respective gels and mediums to achieve a level of finesse that has traditionally been the domain of oil paints.

The great thing about acrylics is their versatility. They can be used in varying degrees of thick and thin within the same painting, and you aren't beholden to many of the traditional rules that can hamper other media. And with the addition of the new slow-drying (open) paints, acrylic artists now have a whole range of drying-time options that weren't available to them before.

The artists included in this book all have distinctive approaches to working with acrylic paints and techniques they have developed over many years of trial and error. They are happy to share that expertise with you. In fact, I am going to give you one of my top secrets for painting success right now: Paint all the time! The more you practice, the more informed your technique will become, and the better your artwork will be.

Happy painting!

MEMENTO/JONES GAP II
Phil Garrett | Acrylic on canvas | 36" × 36" (91cm × 91cm)

Visit artistsnetwork.com/insideacrylics to download free desktop wallpapers.

tools and supplies

Acrylic paint has such appeal to me and the other artists in this book because of its versatility. An artist can paint on paper, canvas or linen, and vary the approach on all those different surfaces with the same set of acrylic paints.

This chapter will cover the tools, materials and studio set-ups that I feel are essential to the contemporary acrylic painter. Over time, as you progress in your own creative process, you will discover other tools and methods of your own.

MEMENTO NIKKO
Phil Garrett | Acrylic on panel | 36" × 36" (91cm × 91cm)
Private collection

easels and work tables

Painting is physical work and demands a working set-up that affords ease of movement and the ability to work in relative comfort for extended periods of time.

The options for easels and work tables (taborets) are varied. I use several easels in my studio—a large double-masted easel that cranks up and down for large canvas and heavy panels, a windmill-type easel that allows me to spin a painting as I work on it (great for glazing large areas upside down to avoid drips!), and an easel that can be vertical or lay flat.

I have several work tables as well. I use a heavy wooden table on large casters for starting smaller paintings, building panels and varnishing. I have a metal kitchen island table on casters that serves as my palette and has storage underneath for gels, mediums, grounds and larger containers of paint.

I also have vertical storage for finished work, flat files for works on paper and enumerable other storage systems for paint, brushes, source materials, etc.

MY SET-UP
An artist's heaven is an uncluttered, well lit space. At least that's what I hear!

paints

Paint is basically made up of two things—pigment and binder. The pigment carries the substance or color. The binder forms the film that adheres that substance or color. A high-quality pigment will be the same or similar in all professional-grade artist paints. The difference between the different types of paints is related to the binder, not the pigment.

The binder for acrylic paint is a mix of acrylic solids in water. Acrylic binder is very flexible and structurally suitable for a lot of different supports—from stretched canvas to solid panels to walls. With the same system of acrylic paints, an artist can paint on paper, canvas or linen with various approaches on all of those different surfaces. It can be thinned with water and used like watercolor or thickened with gel to do incredible impastoed painting knife work.

Acrylic paints come in various formulations. The most common types that we'll focus on for the purposes of this book are heavy body, fluid and the new open (slow drying) acrylics.

HEAVY BODY ACRYLICS

Heavy body acrylics are thick and creamy. They are meant to be used like tube oil paints. Heavy body acrylics thin much easier with acrylic medium than they do with water.

FLUID ACRYLICS

Fluid acrylics work best for smoother applications and are easily thinned with water to make watercolor-like washes.

OPEN ACRYLICS

Open acrylics are similar in consistency to heavy body paints and have the advantage of a longer drying time. This can make it easier to control blending and glazing.

mediums and gels

I teach a workshop on acrylic-like oils. One of the first things I tell my students is that if you want a rich vibrant paint, do not use water as a thinner. Because acrylic binder is made of water and acrylic solids, adding more water to the mixture upsets the balance of solids to pigment, resulting in a flatter and duller paint.

Obviously, if you are using acrylics like watercolor this doesn't apply. For most of what we will focus on in this book, however, adding some other form of binder is essential. Polymer mediums and gels come in many variations and work well as binders for keeping a rich paint application. Let's look at some examples.

POLYMER MEDIUM

Extending acrylic paint with polymer medium retains color richness and superior paint film quality.

SOFT GEL

Adding a clear soft gel to a heavy body paint can extend it and alter consistency to help with brushability.

MATTE GEL

Adding a thick matte gel such as an extra heavy or high solid works well for palette knife work and also imparts a wax-like (encaustic) look to the paint.

brushes

There are many brush options for the acrylic painter, as the quality and variety of brushes has climbed steadily over the last decade. For the most part, acrylic brushes are made with synthetic hair or bristles. Their shapes, as well as the level of softness or stiffness, relate to the way they are used.

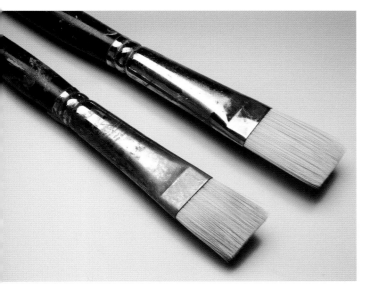 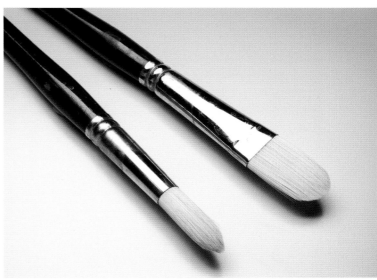

FLATS AND BRIGHTS
Long-handle stiff hog bristle or synthetic flats (long hair brushes) and brights (short hair brushes) are great for manipulating heavy body paints or mixtures of paint and thick gels for both smooth and textured applications.

FILBERTS AND ROUNDS
Stiff filberts (flat brush with a rounded tip) and stiff rounds (rounded brushes) work best for finer manipulation of heavy body paint or fluid acrylics.

Soft synthetic or natural hair filberts are great for fine blending and detail. I particularly like using soft synthetic filberts in large (no. 30) to medium (no. 12) to manipulate wet glazes and blend open paints.

Soft rounds work well for fine detail and crosshatching techniques.

DON'T THROW THAT BRUSH AWAY!
Notice that some of my brushes have black tape on the handle. I tend to use brushes in a forceful way, and occasionally even premium brushes can develop a looseness in the ferrule. When this happens, don't throw away the brush—black plastic electrician's tape is a handy and waterproof repair.

palette knives and colour shapers

Palette knives are essential to mixing and applying paint. I also regularly use silicon rubber-tipped Colour Shapers in several different shapes and degrees of softness to create interesting textures and strokes.

PALETTE KNIVES

I use plastic palette knives for mixing because dry paint can easily be removed from them. I use stainless steel palette knives in a range of sizes and shapes to actually paint with.

COLOUR SHAPERS

Colour Shapers are excellent tools for drawing into wet paint, as well as for shaping and creating texture in mixtures of thick gel and paint. Round-tip Colour Shapers make fine lines, and the angle-cut and chisel-point Colour Shapers can make broad lines and be used to apply paint. Wide Colour Shapers are great for scraping or applying paint.

supports and grounds

Acrylic painters can work on canvas, paper, wood, ceramic, hardboard (Masonite), fiberglass and Plexiglas, but stretched canvas or linen is still the most popular support for acrylic painting. Both canvas and linen are lightweight, and the pre-stretched imports are inexpensive and readily available.

I worked on canvas or linen for most of my painting career, but switched to solid supports exclusively after attending a lecture about their advantages.

I usually buy pre-made or custom-made wood panels or cradled hardboard for larger pieces. They can be heavy, but they are stable and not easily pierced. Because they are flat and level, my varnish applications are much more uniform.

It is important to understand the different terms as related to supports and grounds.

- **Support:** The thing you are going to paint on. It can be stretched canvas or linen, a solid wood or plywood panel, a fiberglass panel, rag paper mounted to a solid support, or honeycombed aluminum.
- **Substrate:** The actual canvas, linen, wood, metal, fiberglass, paper, etc., layer that will be primed to accept the paint.
- **Ground:** A stable absorbent surface that the paint can adhere to. For acrylic painting, that is usually acrylic gesso.

- **Primer/sealer:** A coating applied to seal a surface. For substrates that are going to be used with acrylic paint, it is best to seal the surface with two layers of GAC 100 before applying gesso. This will prevent a support-induced discoloration (SID), which can affect transparent glazes and thick gel applications.
- **Gesso:** Gesso is a type of ground. When I mention gesso in this book, I mean acrylic gesso. It is the standard ground that is used by most acrylic painters. There are a variety of options, from white and black to canvas-colored, and from formulas for flexible supports to hard sandable gessos for panels made of wood, metal or Plexiglas. (True gesso is a ground used for painting with oil or tempera.)
- **Imprimatura:** A toned or colored ground. It is more inviting than the glacial white gesso ground and can provide a midtone to work against light or dark.
- **Stretcher:** A frame built of beveled wooden strips with slotted and adjustable corners.
- **Strainer:** A frame built of beveled wooden strips with fixed corners.

ASSORTED SUPPLIES FOR STRETCHING CANVAS OR LINEN

Supplies include a metal square, canvas pliers, a rubber-headed mallet, a heavy-duty staple gun, a center-reading tape measure and un-primed artist's linen.

Stretch a Canvas or Linen

Many painters opt to use pre-stretched and primed linen or canvas supports. I prefer to stretch and build my own so that I can be in control of all aspects of my painting to ensure the quality and longevity of my materials.

materials

½-inch (13mm) staples | acrylic gesso

artist-grade raw canvas or linen | GAC 100

heavy-duty staple gun | metal carpenter's square

rubber hammer | stretcher bars

tape measure | wide synthetic brush

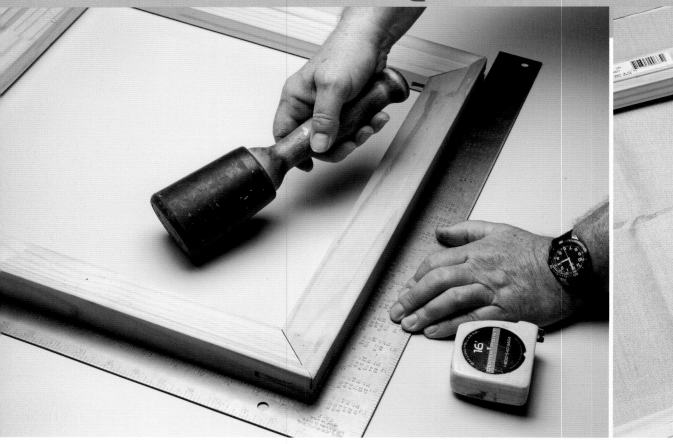

1 CONNECT THE STRETCHER BARS

Before you begin, double-check the length of the stretcher bars. If it is a rectangle, keep in mind that you need a long side and a short side. Connect the slotted corners of each half and then connect the halves. Lay the stretcher inside a carpenter's square. Tap the corners gently with a rubber hammer to square the frame.

Check the diagonal measurement with the tape measure. Put a couple of staples across each corner of the bars to hold everything in place while you stretch the fabric.

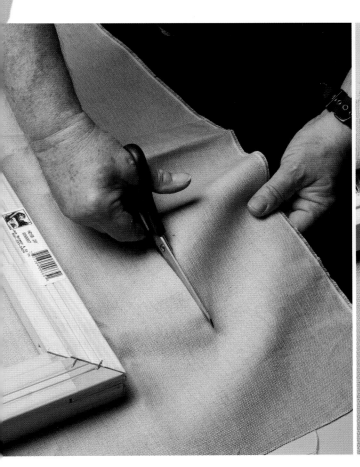

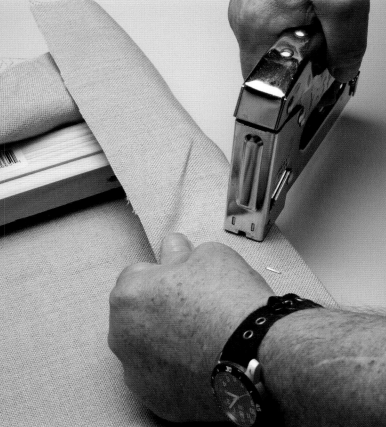

2 TRIM

Trim the canvas or linen to fit the squared-up stretcher bars. Be sure to leave enough fabric to pull over and staple on the back.

3 STAPLE THE CANVAS

Center the stretcher and pull the overflow of fabric all around the sides and back of the stretcher pieces. Staple the canvas to the stretcher on each side, making sure the line of the weave is straight. Work from the center out, stopping short of the corners.

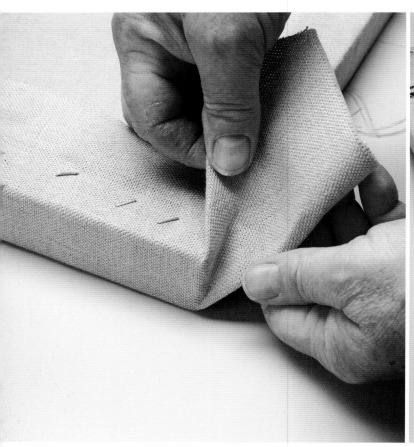

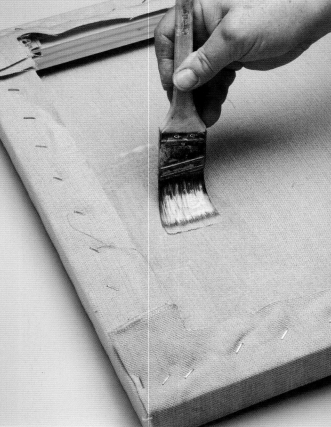

4 SECURE THE CORNERS

Fold the fabric corners back and under, and staple them to the back of the stretcher. Leave a seam along what will be the bottom or top of the painting.

5 APPLY THE SEAL

Use a wide synthetic brush to coat the front and back of the linen with GAC 100. Let it dry, then apply one more coat to the front. Once that is dry, you are ready to go. Sealing the linen this way will prevent SID and provide a surface that lets you keep the acrylic paint working longer.

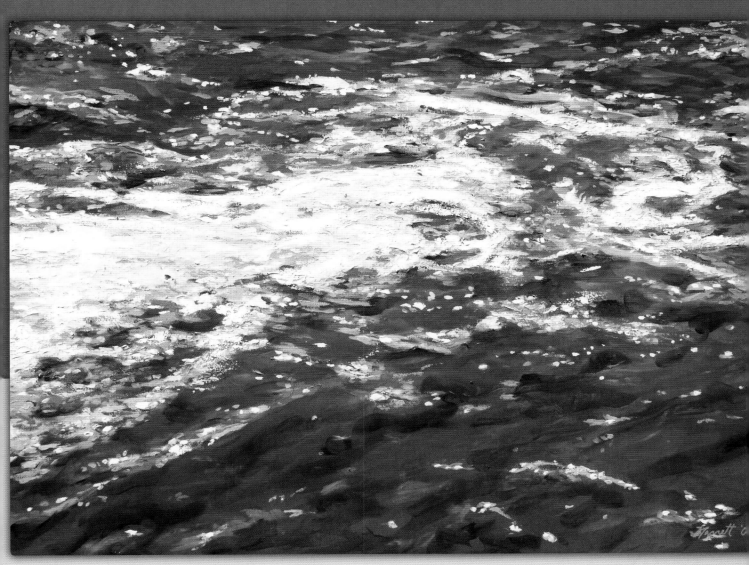

MULTIPLE MEDIUMS CAN BE USED WHEN BUILDING UP LAYERS

I started *Spillway III* with an earth-red ground in fluid acrylic thinned with GAC 100 over a gesso ground. Subsequent layers were built up using fluid and heavy body paints, glazed in between with a mixture of fluid acrylics and acrylic glazing liquid. The last layers, applied with stiff brushes and painting knives, consist of heavy body paint thickened with extra heavy gel matte and extra thick paste paint made by Golden.

SPILLWAY III

Phil Garrett | Acrylic on linen | 40" × 54" (102cm × 137cm)
Collection of Ritz-Carleton Hotel | Charlotte, N.C.

Prepare Solid Panels

Solid panels are my favorite painting supports, and there are many advantages to using them. Solid panels can be primed and sanded for a smooth surface that shows little or no texture from the brush, or they can be textured and scraped with gel for dramatic surface detail and paint build-up. Artist linen, canvas or paper can be applied to the surface. The surface is stable, so fabric won't give. I use several types of panels, from wood to gesso boards, and custom hardboard panels made by Ampersand.

materials

½-inch (13mm) staples

hardboard panel or smooth wooden panel

artist linen (pre-cut) | GAC 100

heavy-duty staple gun | soft gel gloss

soft, wide synthetic brush

stiff, wide wallpaper brush

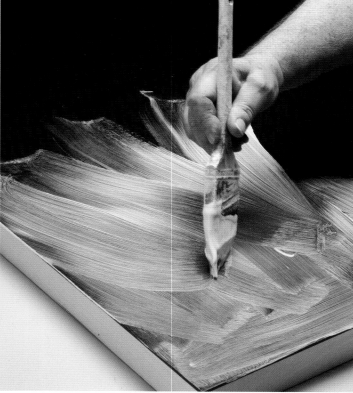

1 SEAL THE PANEL

Using a soft wide synthetic brush, seal the front and sides of the panel with GAC 100. Once dry, apply a second coat of GAC 100 at a right angle to the first coat to get an even coverage. Allow several hours for it to dry. (I usually work on more than one at a time.)

2 APPLY ADHESIVE

With the wide soft synthetic brush, the coat surface of the sealed panel with a generous application of soft gel gloss.

SURFACE OPTIONS ABOUND FOR ACRYLICS

There are several types of acrylic gels and grounds that can make a distinctive surface for painting.

Molding pastes are gels with a marble dust additive. These are good if you want a hard slippery surface to work the paint in an almost monotype, subtractive way. Light molding paste has an absorbency that works well with water-thinned fluid acrylics and airbrush acrylics.

Fiber paste is a gel that has a synthetic fiber additive and dries to form a surface that is reminiscent of handmade paper, yet has the durability of acrylic. This can make a spectacular panel surface for a large-scale painting.

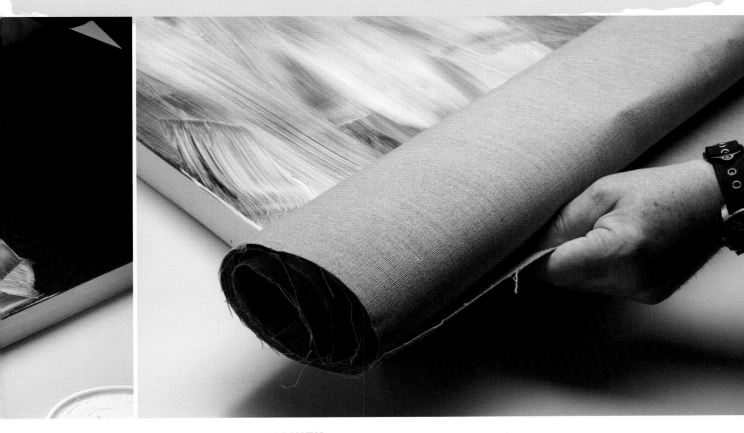

3 COVER WITH LINEN

Carefully unroll the artist linen across the wet surface. Make sure it is centered and that you have enough linen overflow to pull around the sides and staple to the back of the panel. (If you are working on a very large panel, you may need to have somebody assist you.)

4 ADHERE THE LINEN

Using a stiff wallpaper brush, carefully but firmly adhere the linen by brushing across the length and width of the panel. Check the surface for bubbles and work any trapped air towards the corners. You will need to work quickly but calmly.

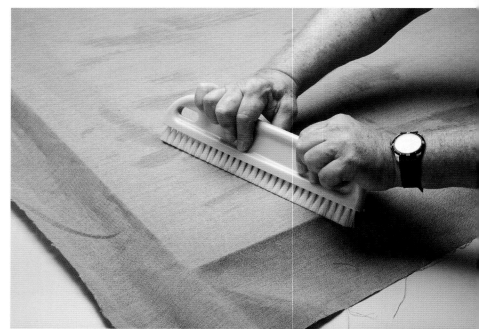

5 SECURE AND PRIME

You'll need a large table with a non-stick surface like melamine. If your table does not have a non-stick surface, cover it with vinyl sheeting to avoid getting any soft gel stuck to it. Place the panel face down on your table and weight it down evenly. I use large full gallons of paint as weights, and usually give it overnight to dry.

Follow the same procedure for stapling the fabric to the sides and back of the panel that you used for stretching a canvas.

Once dry, prime the panel with two coats of GAC 100 and then two coats of gesso. It is definitely a big project, but you will have a superior support for painting.

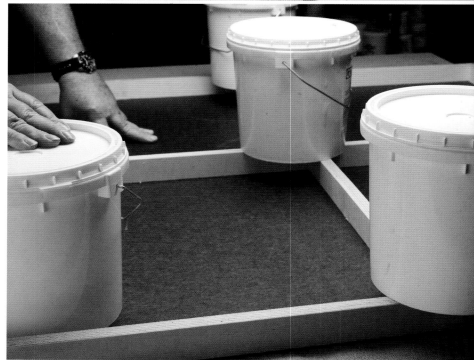

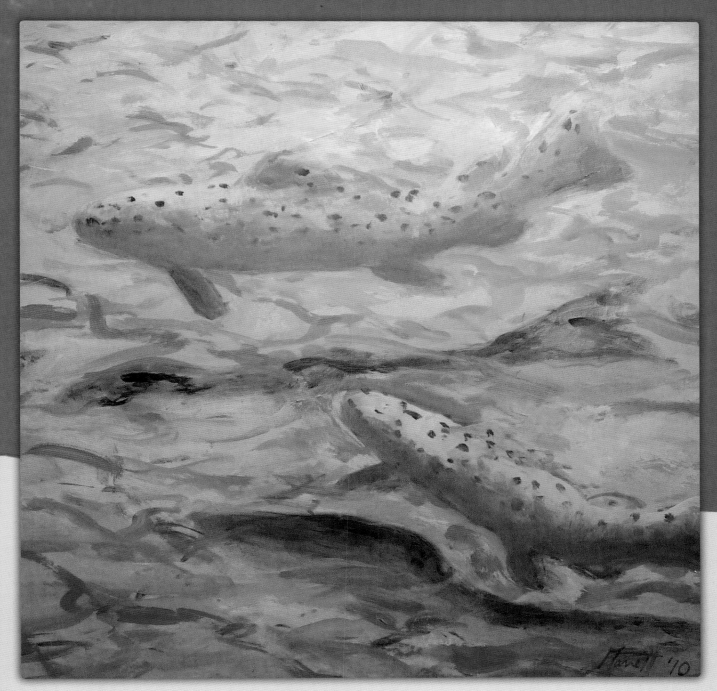

MIX GELS AND PASTES TO CREATE UNIQUE GROUNDS

I use a formula for a hard but absorbent ground that was developed by Mark Golden and the folks at Golden Artist Colors several years ago. The formula is 25% light molding paste, 25% hard molding paste, 25% hard sandable gesso, and 25% water.

This ground needs to be used on a solid support or it may crack. Mix it well using a drill with a mixer bit. Apply the mixture similar to the way you would apply mudding compound, using wide blades and sanding between coats. The result is a beautiful plaster-like surface that absorbs the paint for a very smooth and subtle effect. *Penland Trout II* is painted on that ground.

PENLAND TROUT II
Phil Garrett
Acrylic on panel | 24" × 24" (61cm × 61cm)

ENCOUNTER AT NIKKO

Phil Garrett | Acrylic on panel | 8" × 10" (20cm × 25cm)

CHAPTER TWO

color

The essence of painting is moving colored pigment artfully over a support. Understanding color and how it works can help painters move pigment not only artfully, but with confidence.

I struggled with color concepts in art school and beyond. It wasn't until I had a job in a do-it-yourself frame shop in the late 1970s and had to help people make choices about the colored mats that were in fashion that I began to feel some sense of understanding about the use of color. Through that experience, I began to get a sense of the rhythm and harmonies that you can create with color. If you can create harmonies with color, you can also create discord. That intensity can be just as useful to the contemporary painter.

pigments

In the first chapter, I described paint as a mixture of binder and pigment. Acrylic paint specifically, is a mixture of acrylic solids in water (binder) and pigment (color). Understanding the fundamentals of how pigment works can help you transcend formal color theory, which can be inhibiting at times.

There are two types of pigments—mineral (nonorganic) and modern (organic).

Mineral Pigments

Mineral pigments have been around since early humans first took hollow reeds and blew mixtures of red earth and their own saliva onto cave walls.

Typical mineral pigment is dense and rock-like. Because of its inherent hardness, paint makers usually get a high pigment load, which means that the ratio of pigment to binder is high enough that the pigment breaks the glossy surface of the acrylic binder, making the paint naturally matte and opaque. Mineral pigments have a relatively low chroma (color saturation or intensity) and tinting strength but great covering capability. Typically, mineral pigments are not as clean color mixers as modern pigments are.

MINERAL PIGMENTS
Mineral paints tend to be opaque and have a lower chroma.

(Top) Red Oxide, Burnt Umber, Cadmium Yellow Deep

(Bottom) Burnt Sienna, Chromium Oxide Green, Light Ultramarine Blue

MODERN PIGMENTS
Modern paints tend to be transparent and glossy.

(Top) Nickel Azo Yellow, Quinacridone Nickel Azo Gold, Turquois (Phthalo)

(Bottom) Phthalo Green, Dioxazine Purple, Napthol Red Light

Modern Pigments

Modern pigments came out of petroleum chemistry. If you look at a typical modern pigment particle under a microscope, it resembles a shard of stained glass. Modern pigments are brilliant and transparent, have a high chroma, and are clean color mixers. The pigment load tends to be lower so these paints have a more pronounced gloss than the mineral pigments do.

MINERAL PRIMARIES
Cadmium Red, Cadmium Yellow and Cobalt Blue

MINERAL SECONDARIES
Green—3:1 yellow/blue; Orange—1:2 red/yellow;
Violet—3:2 red/blue

MODERN PRIMARIES
Quinacridone Magenta, Hansa Yellow Medium and
Phthalo Blue

MODERN SECONDARIES
Green—3:2 yellow/blue; Orange—1:2 red/yellow;
Violet—3:1 red/blue

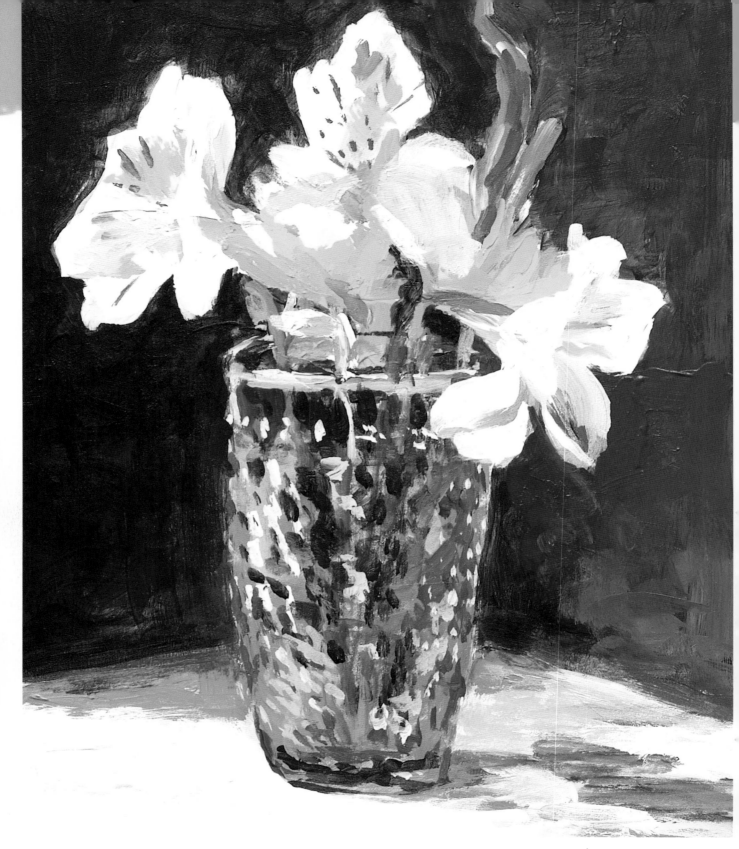

MINERAL VERSUS MODERN PIGMENTS

I painted two simple still lifes to demonstrate the visual difference between using a mineral or a modern palette. Titanium White (a mineral pigment) was used in both palettes. The difference in color intensity is quite apparent. The modern palette is brilliant and the mineral palette is more subdued.

Visit artistsnetwork.com/insideacrylics to download free desktop wallpapers.

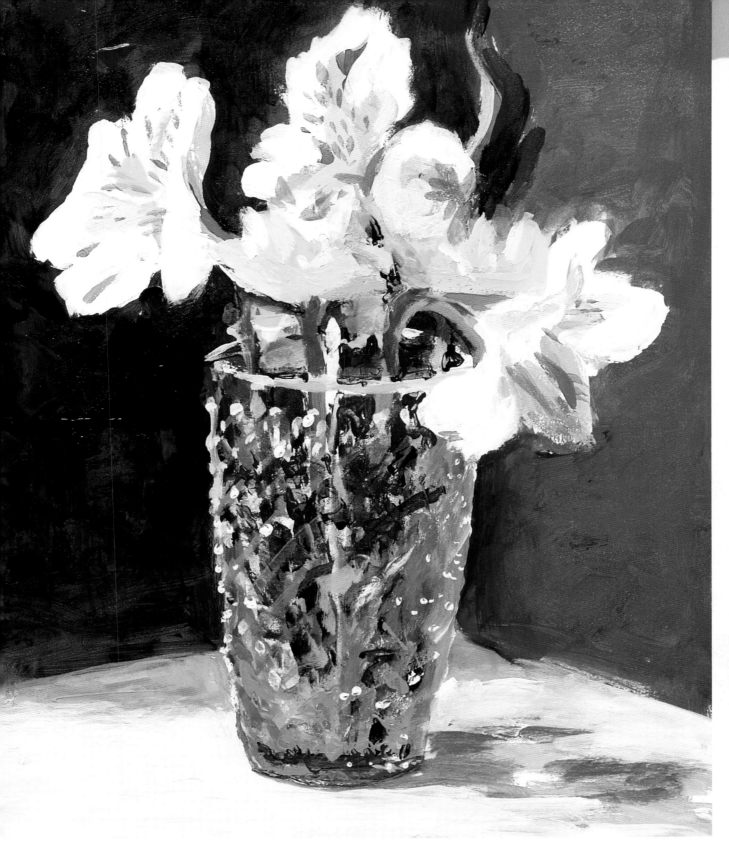

▼ STILL LIFE COMPRISED OF MINERAL PAINTS
Cadmium Red Light, Cadmium Yellow Medium, Chromium Oxide Green, Cobalt Blue and Titanium White

▲ STILL LIFE COMPRISED OF MODERN PAINTS
Hansa Yellow Medium, Phthalo Blue, Phthalo Green, Quinacridone Magenta and Titanium White (mineral)

whites

Acrylic paints offer two options for white—Titanium White and Zinc White. Both are mineral pigments. Titanium White is very opaque and useful for lightning a color and keeping opacity. Zinc White is transparent and can lighten a color without altering the chroma or intensity of the color.

I like to modify the whites that I use in my palette. I was an oil painter for many years and I liked using a stiff white, one that had a lot of body. (When you mix in white, you automatically add body to your paint mixture.)

I found that if I added a thick stiff gel to Titanium or Zinc White, it approximates the stiff oil white that I used. The gels I prefer to add are extra heavy gel (gloss or matte) and high solid gel (gloss or matte). The matte gels approximate adding wax to oil paint and will give you similar sheen and body.

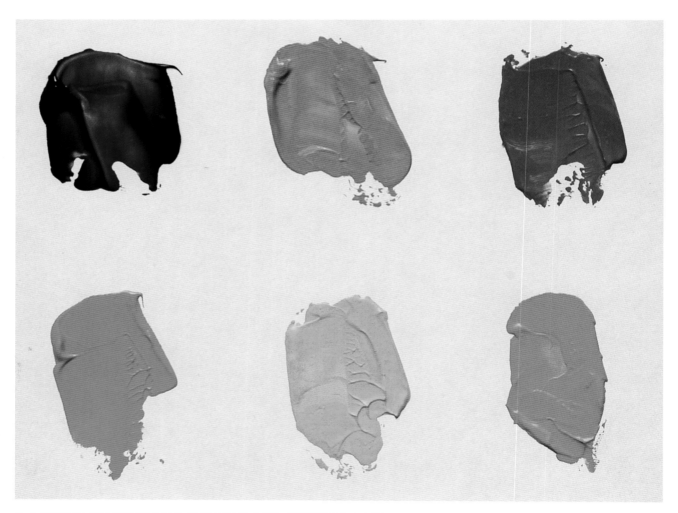

1:1 MIXES OF WHITE TO MODERN AND MINERAL PAINTS
(Top) Quinacridone Magenta full strength; 1:1 mixed with Titanium White; 1:1 mixed with Zinc White
(Bottom) Cadmium Orange full strength; 1:1 mixed with Titanium White; 1:1 mixed with Zinc White

choosing a **color palette**

The term palette can mean the surface (usually non-stick for acrylics) that is used to mix paints on, or the colors an artist chooses to paint with. The latter definition is what we will focus on in this chapter.

The choice of color palette tends to vary according to subject, mood and, in many instances, knowledge gained through painting experience. A good basic palette for acrylic painters could consist of Quinacridone Magenta, Hansa Yellow Medium, Phthalo Blue, Phthalo Green, Napthol Red, Light Yellow Ochre, Titanium White and Zinc White. I would add Payne's Gray, Ultramarine Blue, Nickel Azo Gold, Quinacridone Violet and Raw Umber to this group.

Let's take a look at some of the palettes that are used by the artists in this book. Hopefully their strategies can help you in choosing and organizing your own color palette. As you will see, each artist has his or her own take on organizing a palette, but one common thread is separating warm and cool colors.

PALETTE ARRANGED FROM DARK TO LIGHT MIXTURES

JOHN HULL'S PALETTE

John Hull uses a large glass slab as a mixing palette. He organizes his colors warm on the bottom and cool on the right. He saves any leftover color by misting with water and covering with plastic wrap.

MIKE WILLIAMS' PALETTE

Mike Williams' working palette is open ended. He uses recycled cardboard for his mixing palette and opens all his paint jars at the beginning of the session. He uses the same palette for several sessions and then replaces it with fresh cardboard.

LINDA FANTUZZO'S PALETTE

Linda Fantuzzo uses a disposable palette and lays out warm colors across the top and cool colors down the left side. She may replace a palette several times during a painting session. At the end of the session, she uses a spritz of water and plastic wrap to save any leftover paint.

EDWARD RICE'S PALETTE

Edward Rice uses disposable palettes. Notice the way he has organized his paints from dark to light mixtures with Titanium White across the palette and warm to cool colors down.

MY PALETTE

I use a disposable palette that fits inside a Masterson palette. The Masterson has a lid that is airtight and keeps the acrylic paint from drying out. I have four of these and usually keep warm color mixtures separate from cool color mixtures.

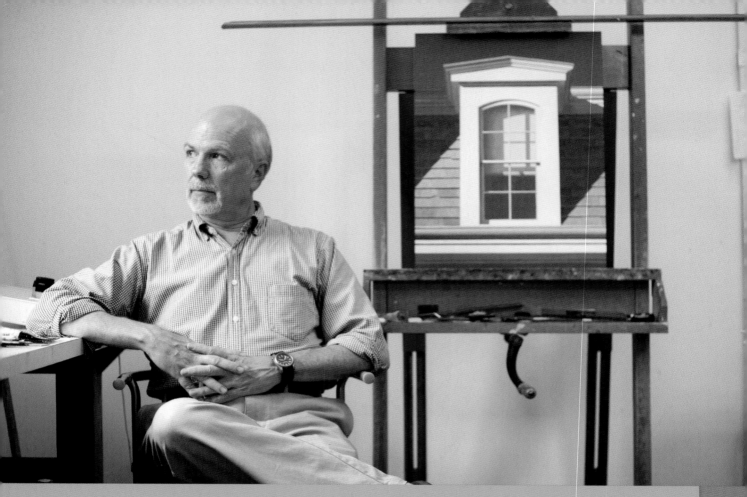

edward rice's working process

Edward Rice is a painter from Augusta, Georgia. The subject of his paintings is Southern architecture. His paintings are precise and his palette is refined. He uses open acrylics and a medium gel that works with slow-drying acrylics. His color choices come from many years of experience in painting his subjects. They also illustrate that you don't need every color to make rich and sophisticated paintings.

Edward's painting, *Dormer, Afternoon*, has a support that is a prepared Masonite panel sealed with GAC 100 and primed with acrylic gesso. The drawing was carefully measured and drawn with a straight edge and a compass. The underpainting was done using Raw Umber and Titanium White thinned with GAC 100. He established all tonal juxtapositions as well as surface. For the surface of all areas depicting white wood, Edward used a hog bristle brush and applied the white as thickly as possible. For all other areas, he used a flat sable brush and kept the paint thin. After the underpainting dried, he began in color.

Edward's palette is fairly simple—one blue, one purple, one red, one orange, one yellow, one green and one white. His color choices, minimal though they are, give him exactly what he needs. Most of the other artists in this book, myself included, tend to use a very broad palette or one that relates directly to the subject. I think we can all learn from Edward's economical approach.

▲ Edward Rice in his studio with *Dormer, Afternoon*.

▶ **DORMER, AFTERNOON**
Edward Rice | Acrylic on panel
24" × 18" (61cm × 46cm)

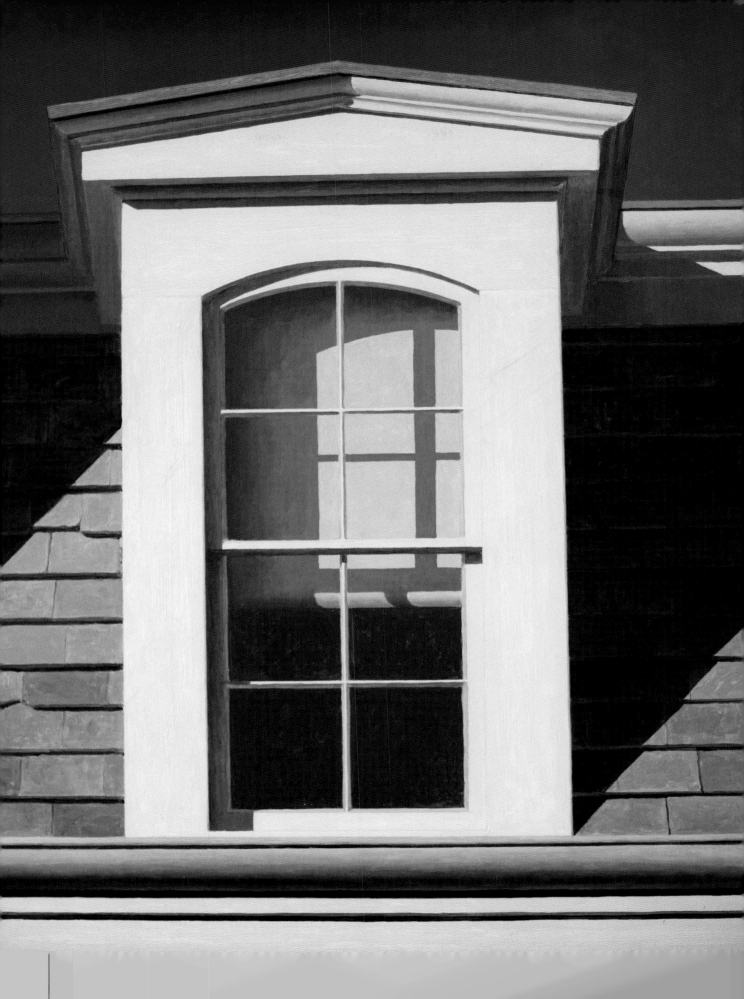

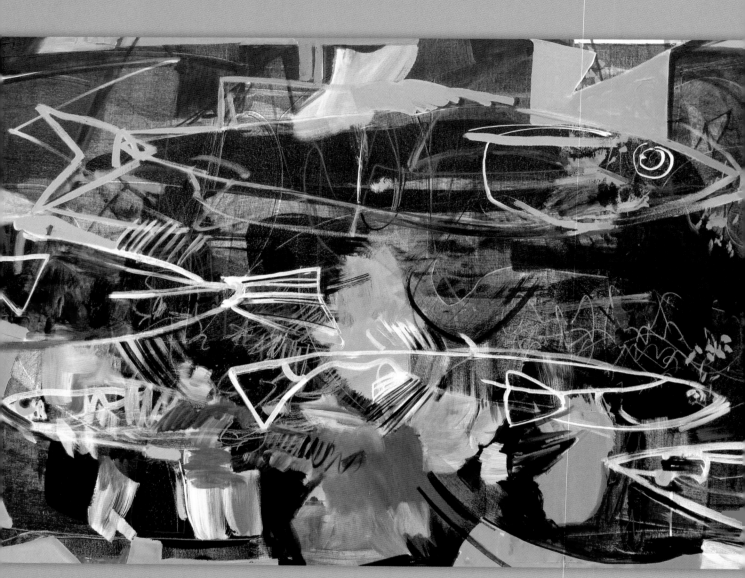

PERIPHERY

Mike Williams | Acrylic and ink on canvas

48" × 72" (122cm × 183cm)

techniques

In the last chapter, I said that the essence of painting is moving pigment artfully over a support. The kind of marks you make on that support, the character of the strokes you use, and the way you apply and organize them is what makes your work unique.

There are dozens of mark-making techniques that can inform and enhance your artwork. This chapter will focus on what I feel are the most important basic painting techniques and explore the various effects you can achieve with them.

DEMONSTRATION
Scumbling

Scumbling is loosely brushing or "scrubbing" thin opaque or semi-opaque fluid or heavy body acrylic over an underpainted area so that the underlying color shows through. This is best done with a long-handled, stiff synthetic or hog bristle flat brush. Scumbling works particularly well for painting skies.

materials

surface | solid panel

open acrylics | Light Ultramarine Blue Titanium White

fluid acrylics | Quinacridone/Nickel Azo Gold

other | stiff synthetic flat brush

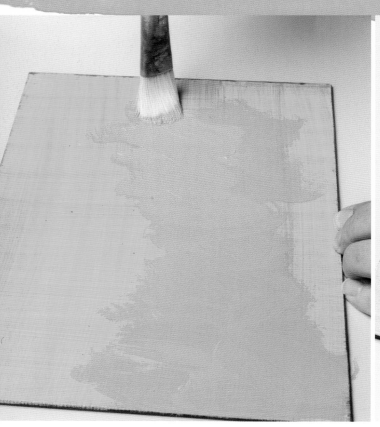

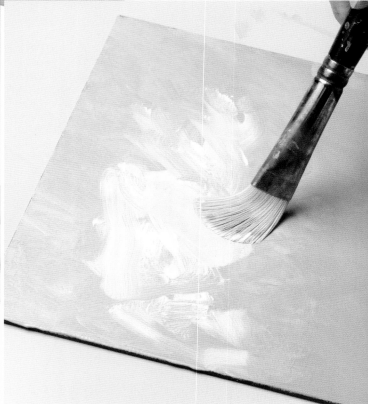

1 WORK OPEN ACRYLICS OVER UNDERPAINTED PANEL
Use a stiff synthetic flat brush to work open Light Ultramarine Blue over a panel underpainted with fluid Quinacridone/Nickel Azo Gold.

2 SCRUB AND BLEND
Add open Titanium White and scrub the blend together.

DEMONSTRATION
Scraping

Scraping or scraping back is a mark-making technique and an effective way to make corrections. It can leave a ghost image that can be layered over and added to with great effect. Scraping uses an assortment of palette knives and Colour Shapers.

materials

surface | solid panel

open acrylics | Green Gold
Quinacridone/Nickel Azo Gold | Titanium White

other | plastic palette knife
hard rubber Colour Shaper | soft wide Colour Shaper

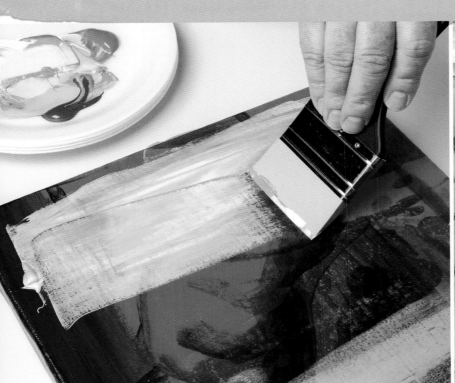

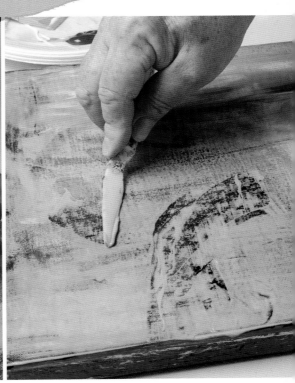

1 APPLY OPEN ACRYLICS TO AN UNDERPAINTED PANEL
Use a soft wide Colour Shaper to apply a mixture of open Titanium White, Green Gold and Quinacridone/Nickel Azo Gold over an underpainted panel.

2 SCRAPE OUT DETAILS
While the paint is still wet, scrape out details using a plastic palette knife. If you wish to scrape out wider details, use a hard rubber Colour Shaper.

DEMONSTRATION
Sgraffito

Sgraffito comes from the Italian word meaning "to scratch." Wonderful effects can be achieved by scratching (drawing) into a wet layer of paint and exposing a white or colored layer underneath. You can use virtually anything, from the tip of a brush handle to hard rubber Colour Shapers and palette knives, or even a pencil or hard charcoal that can leave a mark in the incised line.

materials

surface | solid panel

open acrylics | Quinacridone/Nickel Azo Gold Titanium White

other | flat wide synthetic brush pointed Colour Shaper | plastic palette knife

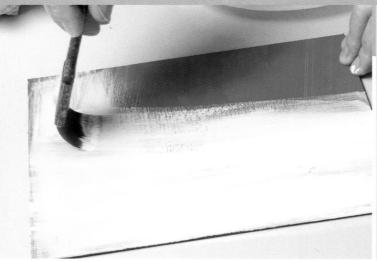

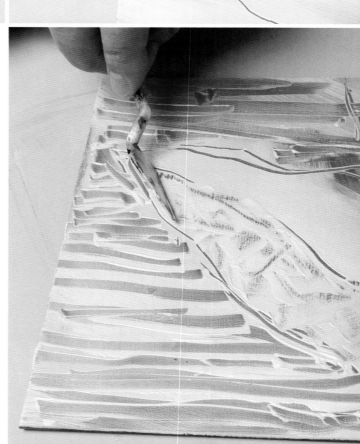

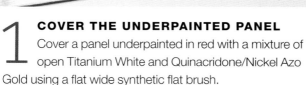

1 COVER THE UNDERPAINTED PANEL
Cover a panel underpainted in red with a mixture of open Titanium White and Quinacridone/Nickel Azo Gold using a flat wide synthetic flat brush.

2 DRAW IN THIN LINES
Use a pointed Colour Shaper to draw into the wet paint, revealing thin lines of red underneath.

3 DRAW IN THICK LINES
Drag the side of a plastic palette knife into the wet paint to reveal thicker areas of red.

Impasto

Impasto is a technique where acrylic paint is thickened with gel and applied with a palette knife or synthetic brush. For this demonstration, we will use the same panel that was used in the scraping demonstration.

materials

surface | solid panel

open acrylics | Light Ultramarine Blue Titanium White

other | high solid gel | plastic palette knife stiff synthetic brush

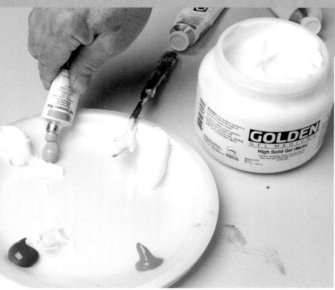

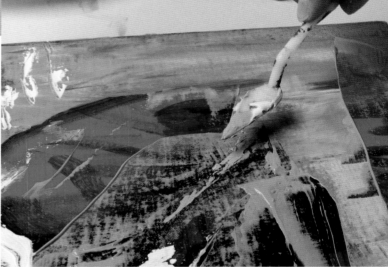

1 MIX THE GEL INTO THE PAINT
Mix an equal amount of high solid gel into heavy body Titanium White and Light Ultramarine Blue.

2 APPLY PAINT WITH A PALETTE KNIFE
Drag the thickened Light Ultramarine Blue over areas of the panel with a plastic palette knife.

3 ADD A BRUSH APPLICATION
Push the thickened Titanium White across the panel with a stiff synthetic brush.

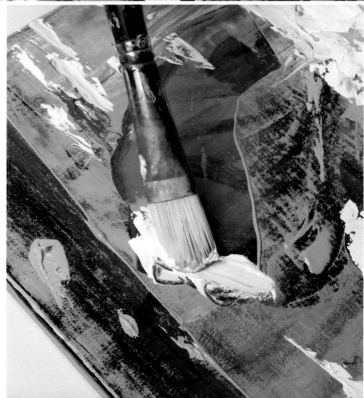

Ragging

I like to paint with a brush in one hand and a rag in the other. That way, I can constantly modify the amount of paint on my brush. I also like to fold the rag into a square, and then again on the diagonal, to make a tool similar to what French painters call a poupe. That folded rag can be wiped to the left or right to blend paint on your surface. The point of the rag can also be used to draw into wet paint and pull out highlights.

materials

non-woven cotton rags or heavy-duty paper towels

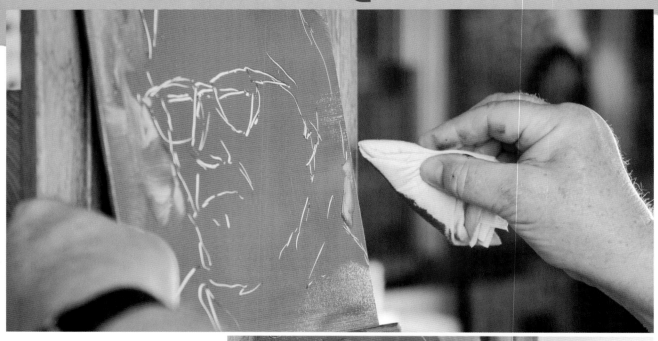

1 DRAW INTO THE PAINT
Use the point of the folded rag to draw into the wet paint.

2 LIGHTEN AND BLEND
Use the side of the rag to lift out highlights and blend wet paint.

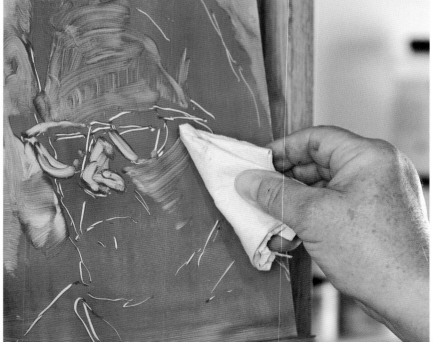

Tonking

Tonking is the removal of a wet paint layer or layers, using a sheet of newsprint. This technique is typically used to refresh an overworked oil painting, but it works just as well if you are using open (slow drying) acrylics. This technique works best if you work on a flat table.

materials
newsprint

wet painting

1 **PRESS THE NEWSPRINT**
Lay a sheet of newsprint (newspaper will work as well) onto the surface of the painting while it is still wet. Gently press against it with a flat hand.

2 **LIFT THE NEWSPRINT**
Gently and evenly pull the newsprint back from the surface.

TONKED PAINTING AND NEWSPRINT PULLOFF
The pulloff can actually make a nice monoprint if you use rag paper instead of newsprint.

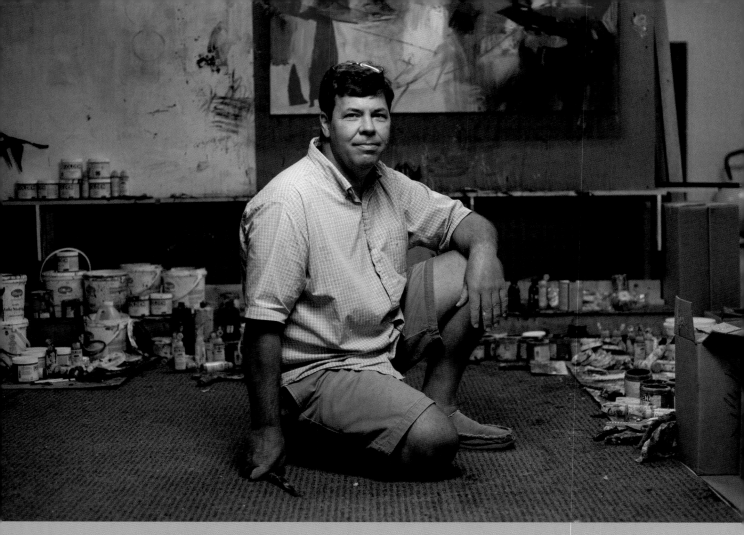

mike williams' working process

Mike Williams is a South Carolina painter whose inspiration comes from his love of the outdoors and fishing. He does not work from reference photos—his imagery is in his mind and heart.

When Mike sets up to work and faces that proverbial blank canvas, he begins by making marks that help him visualize, and then steadily builds on them as ideas come to him. The attributes of the materials he uses help him in building his paintings. He might draw a line into a painting, then fix it by scraping a layer of gel medium over it. Then he might take a large brush and work color over the wet gel and underlying drawing.

Mike works with jars of heavy body paint that he opens well before he starts his painting sessions so that the paint has time to set and thicken. He likes the pull and friction that it gives his brushstrokes. For Mike it's all about the paint and its infinite options for mark-making. Mike usually works on several paintings at a time. He returns to these works in progress over weeks and sometimes months until he is satisfied they are finished.

Let's follow Mike's process for beginning the painting that eventually became *Flow*.

▲ Mike Williams in his South Carolina studio.

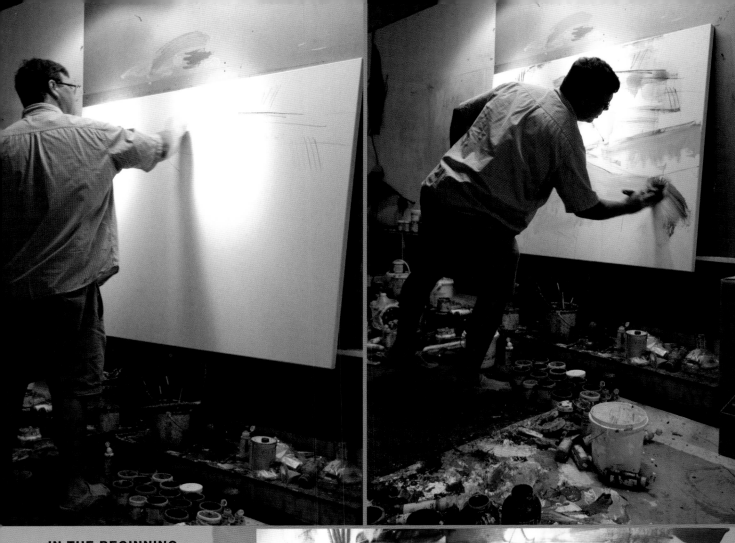

▲ IN THE BEGINNING
Mike sketches his composition with a Stabilo pencil because its marks can be smeared and manipulated. He then uses a scraper to work gel medium over the finished drawing.

◄ APPLYING THE INITIAL PAINT LAYERS
Mike loosely brushes various areas of the painting with heavy body and fluid acrylics, as well as some lightfast colored inks. He uses a range of brush types, from traditional long-handled to house painting brushes.

► ADDING MORE COLOR AND REFINING DETAILS
Mike works in more color and begins to refine details using a brush and palette knife. The shapes of the fish are now becoming apparent.

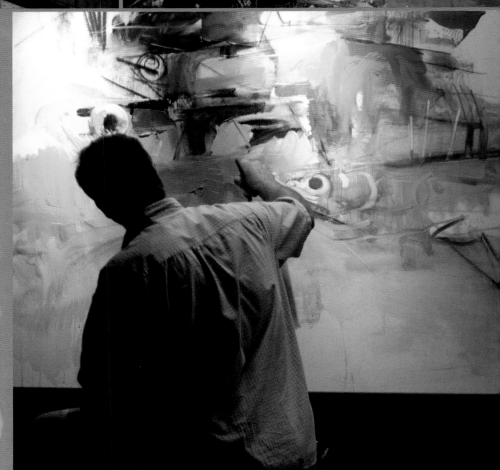

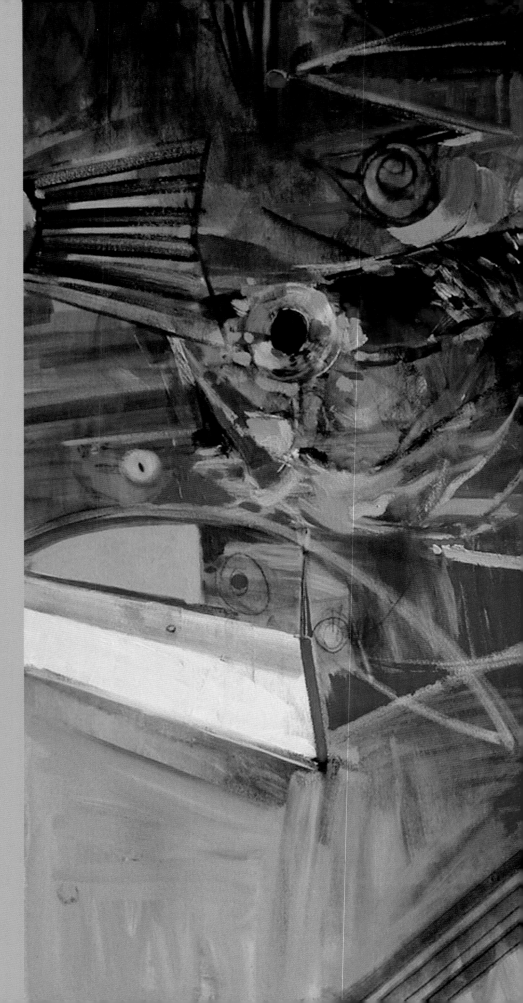

FLOW
Mike Williams
Acrylic and ink on canvas
48" × 60" (122cm × 152cm)

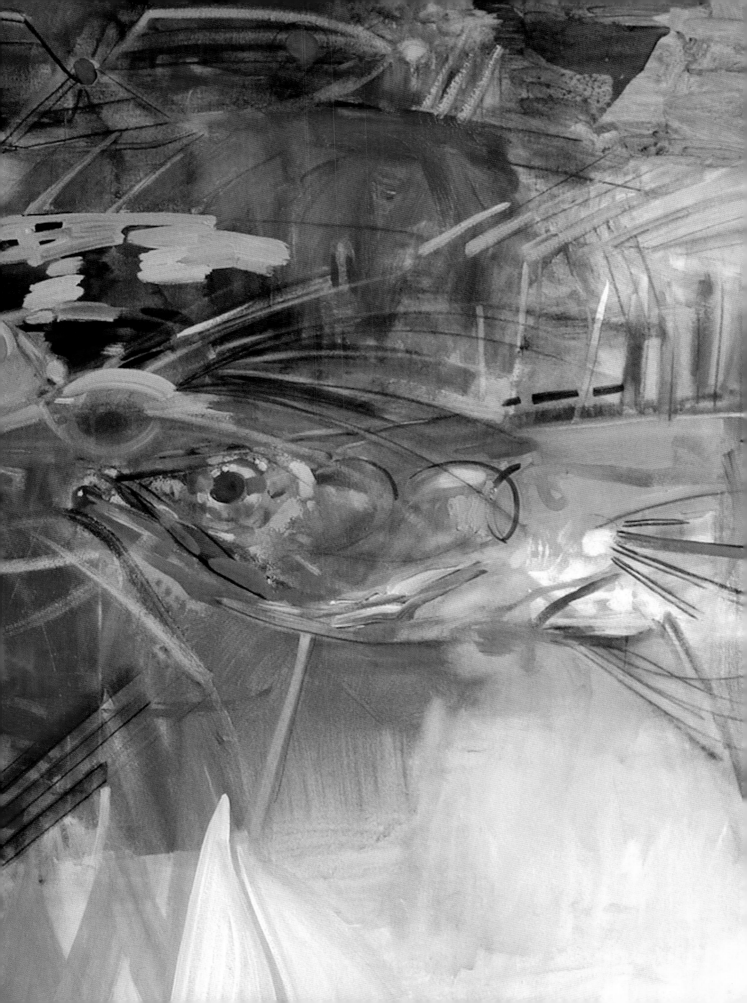

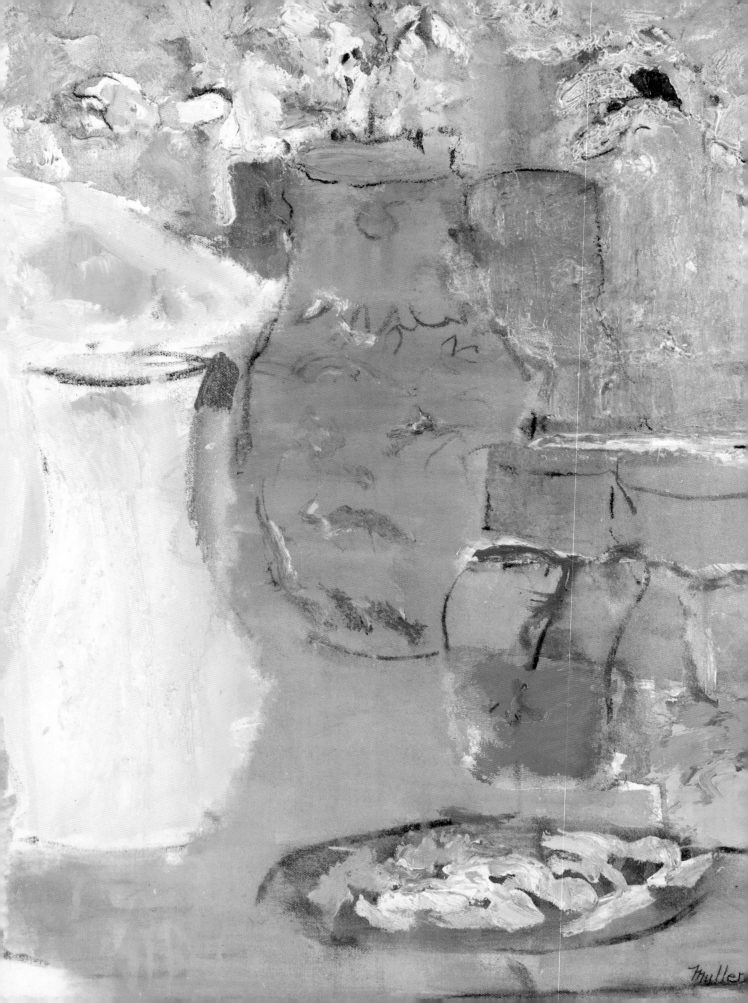

in the **studio**

Linda Fantuzzo, John Hull and Philip Mullen have very different approaches to using acrylics, but all three complete their paintings in the studio. They may do preliminary work outside the studio, but they put it all together in the studio.

For Linda, John and Philip, the studio is not a designated part of a basement or garage, or even a separate room at home. Rather, it is a building unto itself used solely for the creation of paintings—a laboratory for their art. When I visited their studios, I came away feeling an almost sacred respect for the uncluttered space these artists have. I suspect having that order in their workspaces contributes to the intellectual and emotional rigor needed to execute the fine paintings these artists achieve.

ELIELSON'S VASE
Philip Mullen | Acrylic on canvas | 24" × 18" (61cm × 46cm)

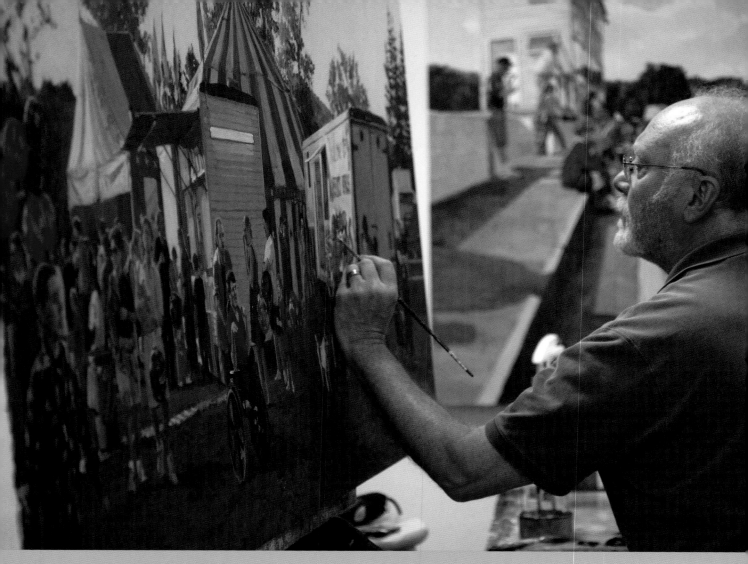

john hull's working process

John Hull is a storyteller first and foremost. The narratives of his paintings can be as dark and mysterious as the best of film noir or as toughly warm as a classic Western. John draws constantly, filling numerous sketchbooks with ideas for the locations, people and animals that will populate his paintings. He chooses subjects from these sources much the way a casting director would.

John's acrylic painting technique is simple and direct and doesn't attempt to overshadow the narrative he has in mind. He uses a simple palette of heavy body acrylics in warm and cool colors. When he needs to thin his paints, he uses polymer medium or, sometimes, plain water. John begins his process with a small preparatory sketch, then creates a scaled-up preliminary drawing on the canvas in graphite. His first layers of paint follow the drawing and are thin and monochromatic. He then begins to build up layers of heavy body acrylic, adding color and some gel for texture as he develops the painting.

What I most admire about John's work is that his stories are open ended, allowing viewers to fill in or shade the story from their own experiences.

▲ John at work on a painting for a series of carnival-themed pieces.

▶ **WILLIE THE WIMP**
John Hull | Acrylic on canvas
36" × 24" (91cm × 61cm)

▲ Even with two paintings in progress, John keeps his work space uncluttered.

► John's numerous sketchbooks are filled with source material.

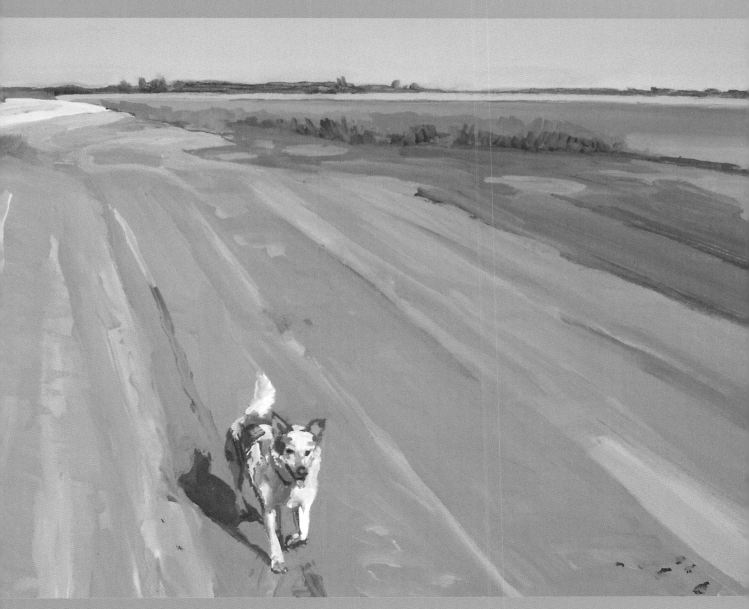

JOHN HULL ON CREATIVE TRANSITION

Five years ago, I moved to North Carolina from the West, a place where I'd painted most of my life. It was a difficult creative transition because my painting ideas had been so tied to Western spaces. Throughout this transition period, I did drawings of my dog and spent time with him at Folly Beach.

The way Forest looked against the landscape reminded me of the paintings of Frederic Remington. In his paintings, Remington tended to use high horizons with plenty of foreground and figures set in the middle ground. I started thinking about Forest at the beach, and I found a way to make some paintings that really interested me, developing paintings where the figure of the dog would be introduced in the middle ground, across the sand dunes and beach grasses with a high horizon and small sky.

FOREST THE THE BEACH I

John Hull | Acrylic on canvas
18" × 24" (46cm × 61cm)

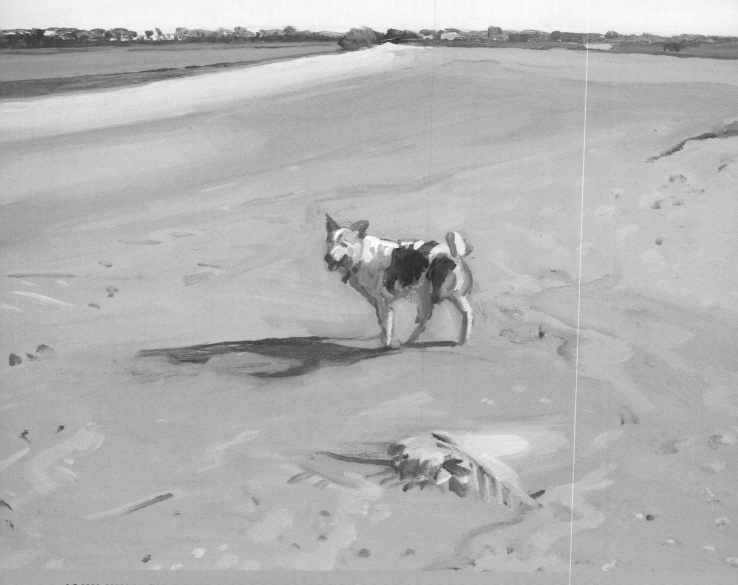

JOHN HULL ON DEVELOPING THE SERIES

I started to draw more seriously, developing compositional ideas. I also began to take panoramic photographs as well as snap shots of Forest on the beach, and make notes on lighting and vegetation in the area.

 The paintings themselves were done in my studio and are based on the compositional drawings, figure studies and photographs I made over a period of several months. I have used Golden heavy body paint for thirty years. For the *Forest at the Beach* series, I sometimes added soft molding paste to the paint to give it body. (Approximately one-part paste to three-parts paint.) Other than that, I used water as a medium.

FOREST AT THE BEACH II

John Hull | Acrylic on canvas
18" × 24" (46cm × 61cm)

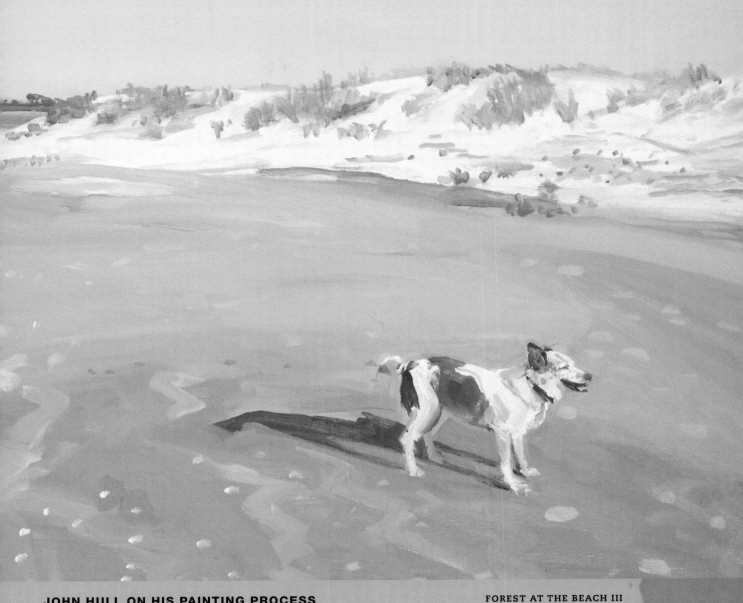

JOHN HULL ON HIS PAINTING PROCESS

The way I work is pretty straightforward. I don't use a lot of gimmicks because I like to watch the painting come together as I work. I have intense periods of rapid painting that last approximately one hour. These are followed by periods of looking at what's happened. I then decide how to move forward based on ideas the painting begins to inspire and suggest to me. I move figures and objects based on the structure of the painting and the way the composition supports the narrative idea.

FOREST AT THE BEACH III

John Hull | Acrylic on canvas
18" × 24" (46cm × 61cm)

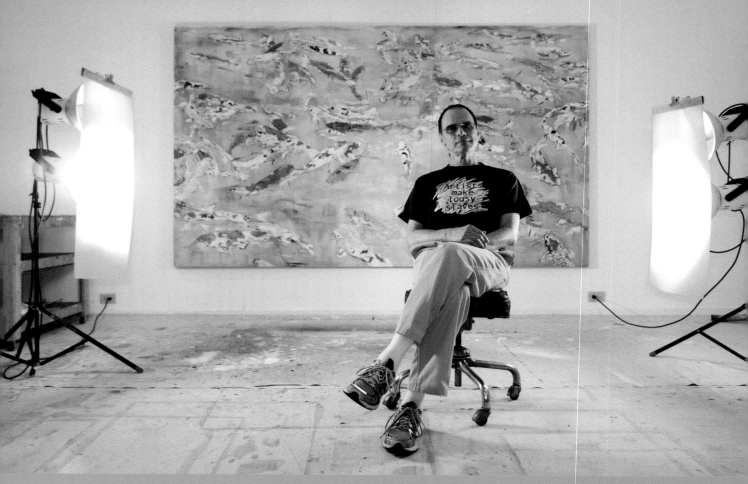

philip mullen's working process

Philip Mullen's approach to painting with acrylics is more about the physical act of applying and removing or editing paint than it is about pictorial storytelling. He uses real images, like koi fish, but he is interested more in the shapes, colors and physical qualities of the paint than in getting a realistic likeness of the fish. He is not interested in traditional depth of field in his paintings, and uses color shapes to establish depth.

Philip usually begins his paintings by applying broad areas of acrylic thinned with water to establish an atmospheric ground. He builds over the top of this ground with a 50/50 mixture of paint and polymer medium or gel, and usually works darks over lights. At that point, and while the painting is still wet, Philip may cautiously rinse the painting with water. This breaks down the paint layers and refreshes the surface so that he can rework specific areas of the painting. He has a clean-up room with a large tub and sprayer off the main painting studio to facilitate this technique.

Typically, Philip's next step in the process is to lay watercolor like washes of acrylic paint and water over the thicker layers of dried heavy body paint and medium, allowing the washes to pull away from the thicker details.

▲ Philip Mullen in his South Carolina studio in front of *Famous Fish*.

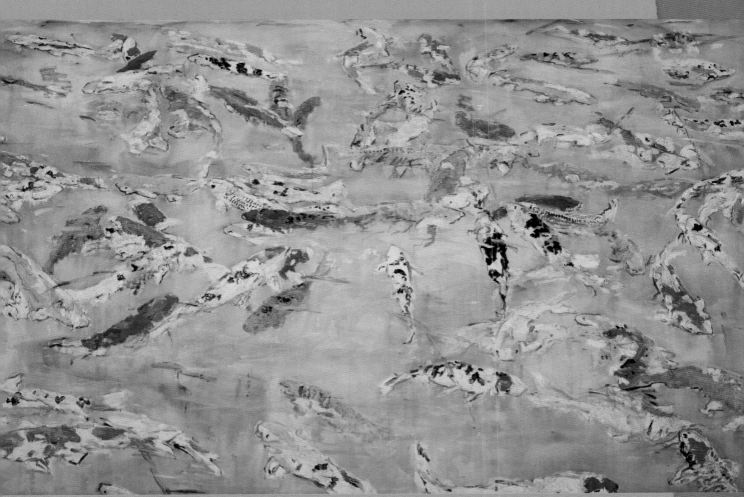

FAMOUS FISH
Philip Mullen | Acrylic on canvas
72" × 120" (183cm × 305cm)

FAMOUS FISH, DETAIL
Notice the way the built-up layers of acrylic and gel with their
transparent washes pull away from the thicker details.

DEMONSTRATION
Staining Paint and Gel Layers

Philip Mullen's technique of staining paint and gel layers with a thinner paint can also be accomplished by using a thin or glaze medium with fluid acrylics. This technique is similar to glazing in oil painting, and it can help to bring out textures and lighter colors in a piece. The benefit of using acrylics is that the artist need not worry about the thin layers potentially cracking over the thick layers. I'll take you through this process using one of my paintings.

materials

brushes | soft long-handled filbert

fluid acrylics | Payne's Gray

other | acrylic glazing liquid | paper towels plastic palette knife

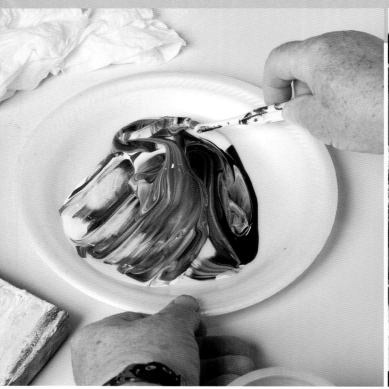

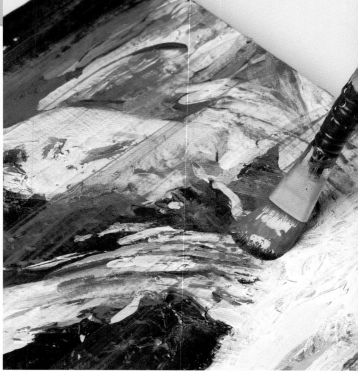

1 MIX THE PAINT AND GLAZING LIQUID
Use a plastic palette knife to mix Payne's Grey fluid acrylic and acrylic glazing liquid in a 3:10 ratio.

2 APPLY THE MIXTURE
Brush the mixture over the top half of the painting using a soft filbert brush. The mixture will get into the peaks and valleys of the dried and gel-thickened paint, making the texture really stand out. Continue working the mixture towards the bottom of the painting. Don't be concerned about it drying too quickly. The acrylic glazing liquid has a controlled amount of retarder in its formula, which gives it a longer drying time. If you are working on a larger painting, use open medium for even more of an extended working time.

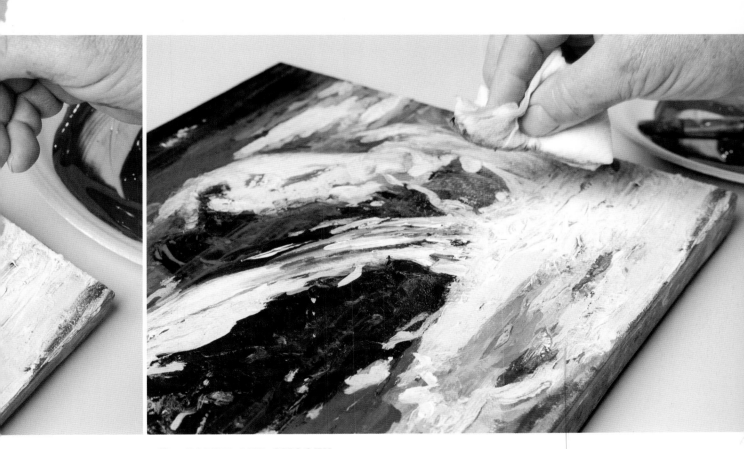

3 BLEND AND SMOOTH
Use a damp paper towel to blend and smooth areas of the painting. It can also be used to remove paint and restore highlights to the paint surface.

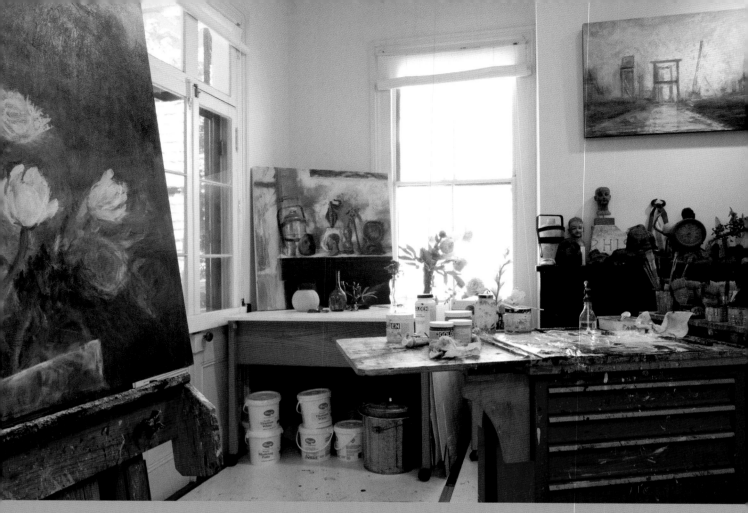

linda fantuzzo's working process

Linda Fantuzzo's landscapes, still lifes, interiors and figures are conjured through her manipulation of paint and inspired by the deep mystery and beauty that drenches the low country of South Carolina where she lives. Linda uses mostly heavy body acrylics thinned with water and medium. She manipulates and removes paint with both wet and dry brushes, as well as dry and damp rags. The build up and removal of the paint layers contributes to the atmosphere in her paintings.

LINDA FANTUZZO'S STUDIO
Linda's painting area with a still life in progress.

Linda Fantuzzo paints in her studio space—an old house not far from the center of Old Charleston, SC.

LINDA'S PAINTING PROPS

Linda found the clay mask, scorched by fire with its nose smashed, a the bottom of a box of clothing from Guatemala. She found its presence surprising and enigmatic, making it a choice item for a still life.

The small wood sculptures are saint's heads from Vietnam that were made in France. They have characteristics of both cultures, and are exquisite in their state of disrepair. Their polychrome paint is flaking, and this imperfection adds mystery to their untold stories, making them perfect for still life.

The bronze faces are life casts that Linda made from the faces of friends.

61

STILL LIFE WITH LANDSCAPE PAINTING
Linda Fantuzzo | Acrylic on cradled birch panel | 30" × 30" (76cm × 76cm)

Visit artistsnetwork.com/insideacrylics to download free desktop wallpapers.

FLORAL LIGHT
Linda Fantuzzo | Acrylic on cradled birch panel | 23" × 24" (58cm × 61cm)

STUDIO SUMMER-1

Jim Campbell | Acrylic on canvas | 42" × 32" (107cm × 81cm)

portraiture

When I hear the term *portraiture*, I think of painting the figure in context. I also think of a more polished and probing painting technique being used to convey a deeper emotional or psychological meaning about the person being painted. Traditionally, oil paint has been the medium of choice for portraiture, mainly because of the long open time (wetness). It allows for fine blending of flesh tones and the leisure of fine-tuning the paint marks and details. The downside of using traditional oils is that they take time to cure before the final varnish can be applied. Long-term exposure to solvent-based mediums and modifiers like oils can also cause health issues.

Acrylic paints offer a great alternative for the portrait artist. The new open acrylics have a working time comparable to oils without the solvent-based mediums or additives. They can be blended and used with finesse for details or complicated passages in a painting. They can also be mixed with the faster drying heavy body or fluid acrylics to give you a range of paint body consistences and working times.

In this chapter we will explore ways of using acrylics like traditional oils.

DEMONSTRATION
Substractive Monochromatic Underpainting

This technique uses a monochromatic underpainting with lights and darks created primarily by subtracting wet paint using rags and dry brushes. When the underpainting is dry, it can be finished with transparent open paint using the established lights and darks as a guide. This can be a very straightforward and economical technique for portraiture compared to the alla prima (wet-into-wet) technique.

materials

surface | 8" × 10" (20cm × 25cm) Ampersand gesso board panel

open acrylics | Burnt Umber | Quinacridone/Nickel Azo Gold

brushes | 2-inch (51mm) synthetic flat | no. 6 long-handled acrylic | no. 14 synthetic filbert

other | fine-tip Colour Shaper | open gloss medium | open thinner | paper towels | plastic palette knife | rag

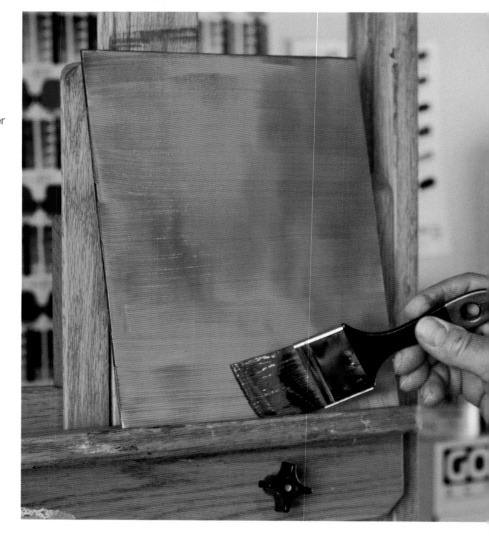

1 APPLY THE BASECOAT

Apply a basecoat of open Quinacridone/Nickel Azo Gold evenly with a 2-inch (51mm) synthetic flat brush on gesso board (pre-primed with gesso). Use enough paint to cover the surface so that no white shows through, but not so thick that drawing or ragging will leave a raised edge of paint.

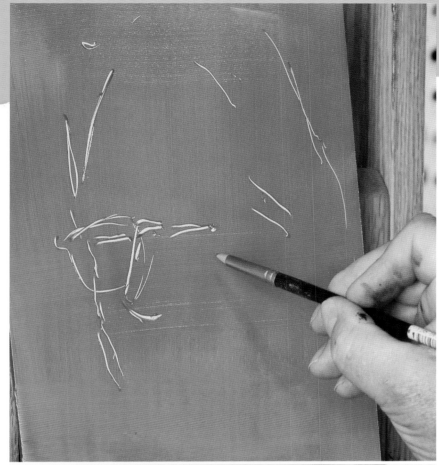

2 SKETCH YOUR COMPOSITION

Sketch the initial drawing with a fine-tip Colour Shaper, or any other tool that won't dig into the surface beneath the paint layer. I also like to use the tip of a folded rag to draw and wipe into and away from the painted surface.

3 LIFT OUT HIGHLIGHTS

Once your initial drawing is complete, use a rag dipped in open thinner to carefully wipe back areas of the portrait to create light values. This method will allow you to get a range of value from dark to light and easily make corrections. You can even do this as much as a day later and still be able to lift out the open acrylic paint.

TIP!

Keeping a mirror clamped to an easel at the same height as your painting panel works well when doing self portraiture.

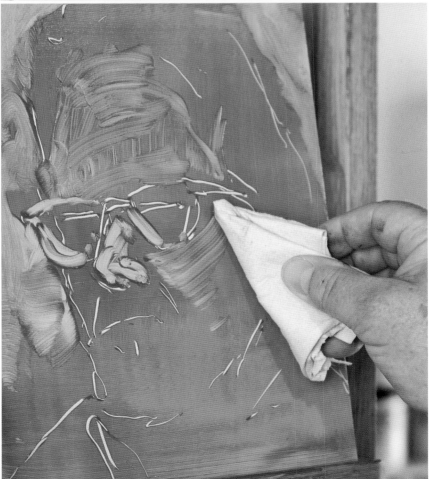

4 ESTABLISH TONES, BLEND AND REFINE

Use rags and dry brushes dipped in open thinner to establish masses and tones in the face and head, with emphasis on the defining features (eyes, nose, mouth, earlobe, hair and glasses). Then use a rag dipped in open thinner to remove most of the Quinacridone/Nickel Azo Gold in the background, leaving a mottled light warm tone around the head.

Use a no. 14 synthetic filbert brush and a small amount of open thinner to blend and fine tune the underpainting.

5 ADD DARK DETAILS AND SHADOWS

Use Burnt Umber and a no. 6 long-handled acrylic brush to add dark details and some shadows.

6 LET IT DRY

At this point you are finished with the underpainting. Don't be concerned if it isn't perfect. You have enough information to begin the next step in the process. Leave this layer to dry for at least a day. The open paint is still curing and you don't want to lift it when you add the next layers.

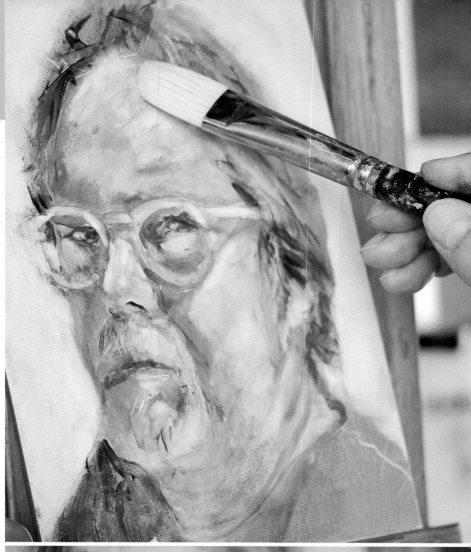

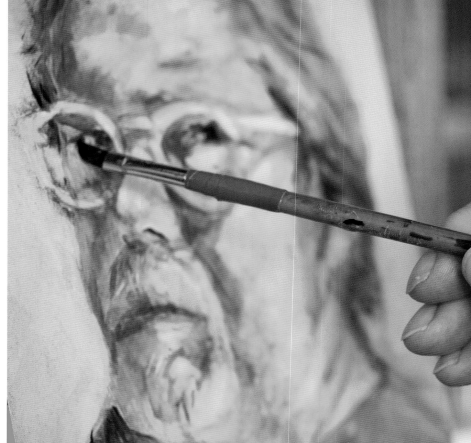

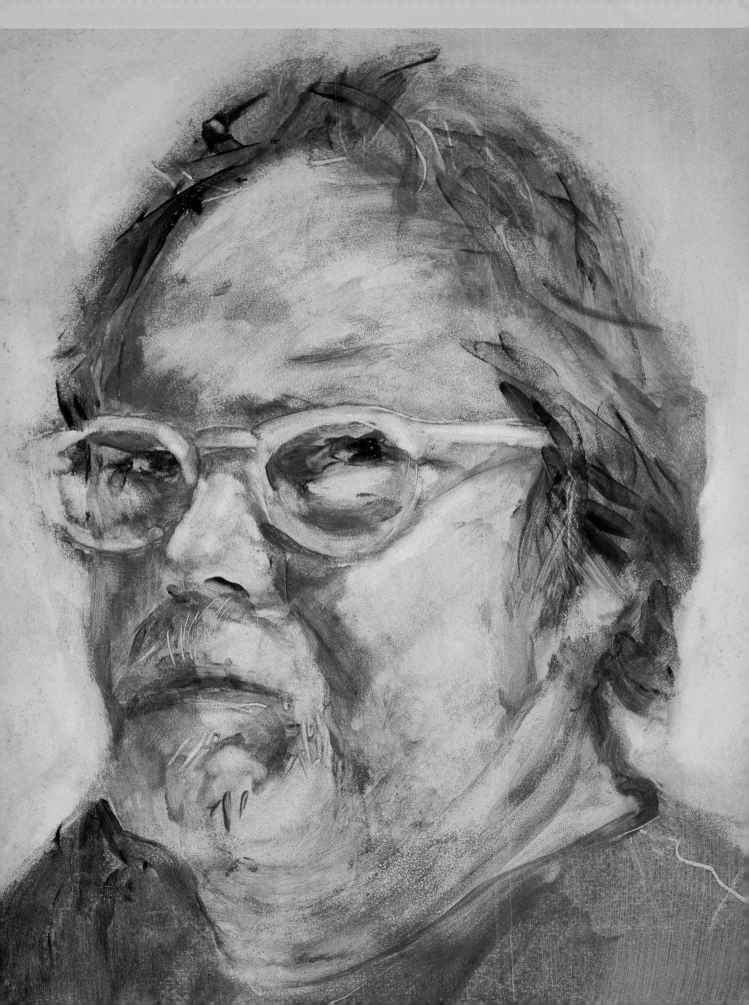

Overpainting With Transparent and Opaque Open Acrylics

Let's move on to the next stage—working layers of open acrylic over the underpainting. At this stage I tend to use a simple color palette, working transparent color over the areas of the painting that I want to change.

materials

open acrylics | Hansa Yellow Medium | Napthol Red (Light or Medium) | Phthalo Blue | Quinacridone Magenta | Raw Umber | Titanium White | Ultramarine Blue | Yellow Ochre | Zinc White

brushes | small and medium long-handled flats and filberts

other | open medium

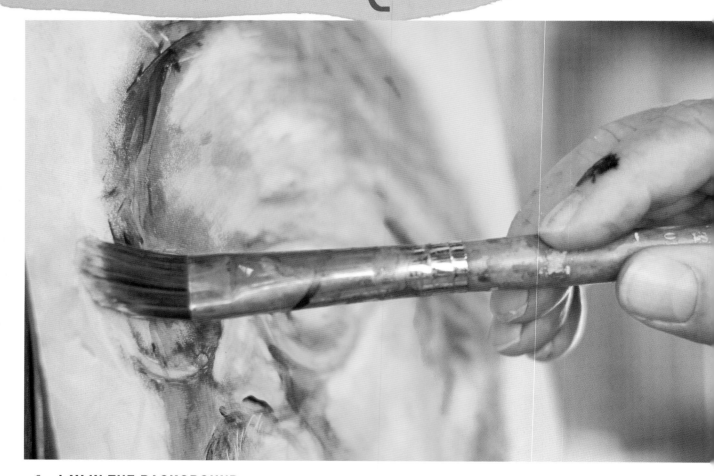

1 LAY IN THE BACKGROUND

Lay in the background with a mixture of semi-opaque Zinc White and Yellow Ochre. Use a medium or large synthetic flat brush to scumble the paint and get a look of soft focus in the background.

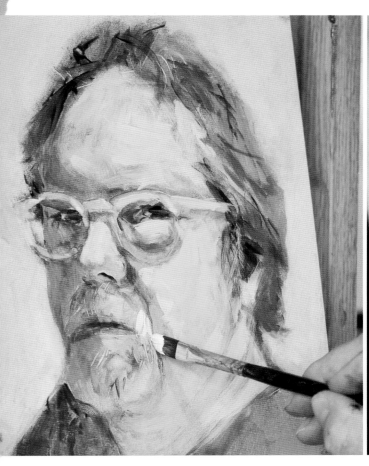

2 ESTABLISH MIDTONES AND HIGHLIGHTS

Using the established lights and darks of the dry underpainting, paint the midtone areas of the face with a medium filbert brush. To get an opaque flesh color, mix Titanium White and small amounts of Quinacridone Magenta, Phthalo Blue, Hansa Yellow Medium and Napthol Red. Use a smaller filbert to add more Titanium White to the flesh color and establish highlights on the forehead, nose and cheeks.

3 ADD DETAILS AND CONTINUE BUILDING COLOR

Use a small or medium filbert to add details using purer transparent colors like Quinacridone Magenta and Phthalo Blue, especially around the nose, mouth and eyes. To darken a color, add a 1:1 mix of Raw Umber and Ultra-marine Blue. To lighten a color, add Titanium White. Leave areas of the underpainting showing to play warm off of the cool opaque overpainting.

DEMONSTRATION
Grisaille Variations

I often use another traditional oil painting technique for portraiture called grisaille, which uses opaque paint to establish a value painting. It can establish real depth in your painting. *Grisaille* comes from the middle French word *gris*, which means gray. You can use a dark gray such as Payne's Gray, but I like to use Cobalt Green for a cool variation or Burnt Umber for a warm variation. Setting up your palette in a logical, orderly way is essential to getting the range of values from dark to light that this technique requires. Let's explore two variations of grisaille that are very useful to the portrait artist.

materials

surface | canvas or solid panel

heavy body or open acrylics
Burnt Umber | Cobalt Green | Titanium White

brushes | small and medium rounds and filberts

other | open medium (slow drying) | polymer medium (fast drying)

1 MIX THE PAINT FROM DARK TO LIGHT

Mix heavy body paint from dark to light. Start with a tube of full strength color. Take about half of that amount and mix with an equal amount of Titanium White. Then take half of that mixture and add an equal amount of white again, and so on until you have a range from dark to light.

Visit artistsnetwork.com/insideacrylics to download free desktop wallpapers.

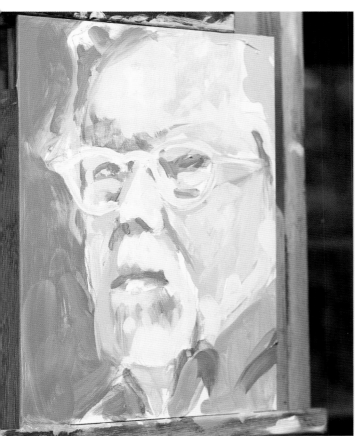
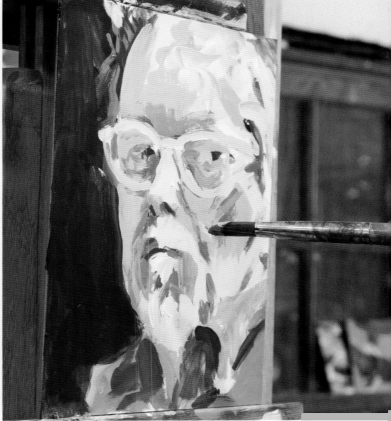

2 PAINT THE GRISAILLE

Establish your value painting using the dark and light values that you mixed in Step 1. Paint over the grisaille with transparent and opaque (white added) color. I lean toward using warm colors over the cool (Cobalt Green) grisaille and cool colors over the warm (Burnt Umber) grisaille. You could also use a palette of color that is somewhere in between.

COLOR PALETTE FOR GRISAILLE

COLOR MIXED WITH WHITE

This palette consists of Phthalo Blue, Dioxazine Purple, Quinacridone Magenta, Napthol Red Medium, Cadmium Orange, Hansa Yellow Medium, Phthalo Green, Yellow Ochre and Titanium White. I have added white in graduated amounts to each of the colors to get a range from dark and transparent to light and opaque.

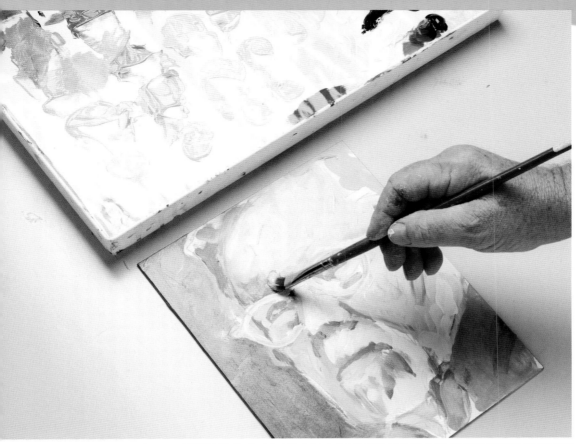

WORKING COLOR OVER THE COBALT GREEN GRISAILLE

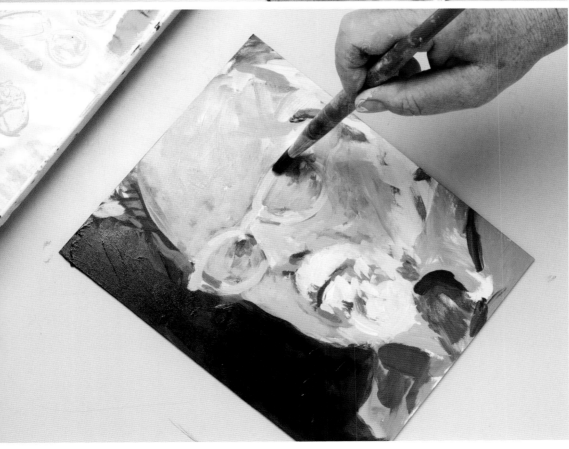

WORKING COLOR OVER THE BURNT UMBER GRISAILLE

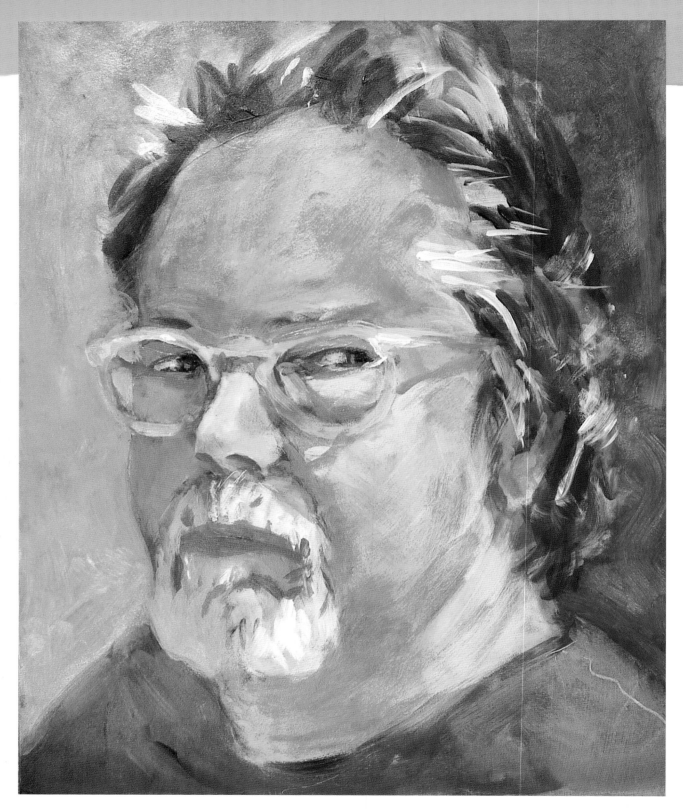

SELF PORTRAIT

Phil Garrett | Acrylic on solid panel | 10" × 8" (26cm × 20cm)

Visit artistsnetwork.com/insideacrylics to download free desktop wallpapers.

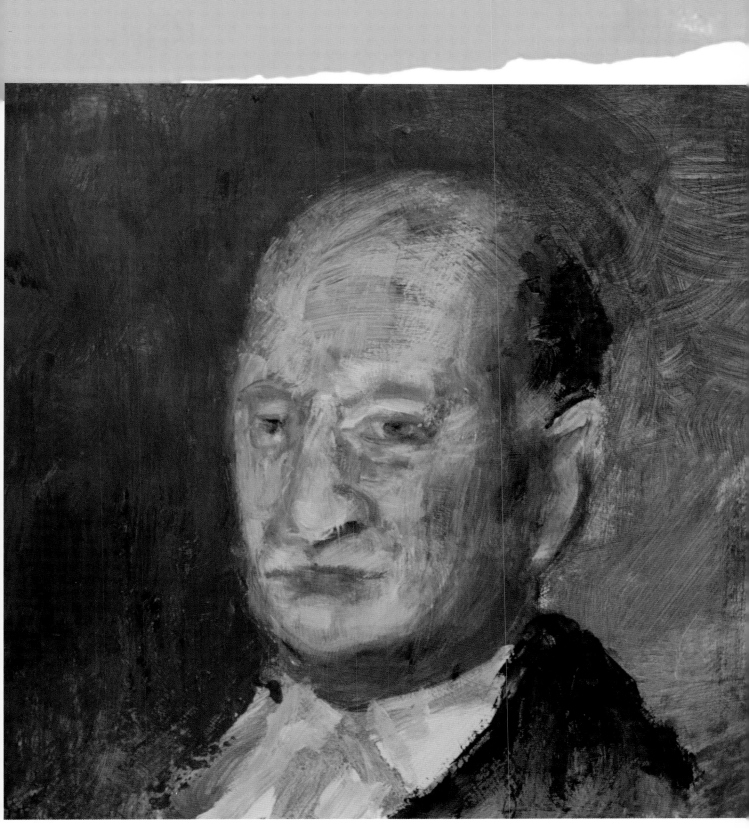

PORTRAIT HEAD

Linda Fantuzzo | Acrylic on birch panel | 16" × 16" (41cm × 41cm)

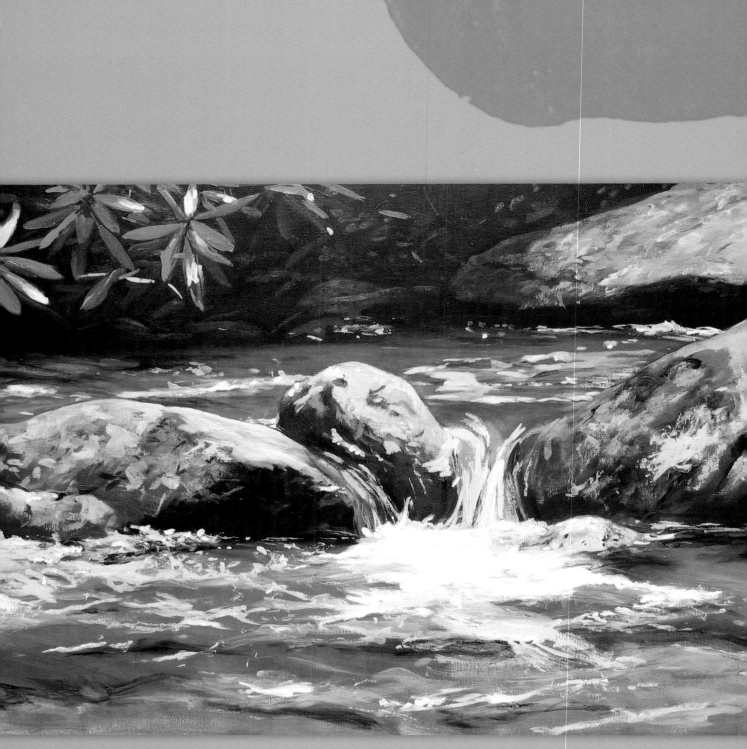

RED ROCKS/JONES GAP

Phil Garrett | Acrylic on linen | 40" × 60" (102cm × 152cm)

Collection of Palmetto Bank

plein air

En *plein air* is a French expression meaning "in the open air," and is used to describe the act of painting outdoors. Artists all have their own particular plein air set-up, but for the most part, keeping it simple and physically light is key. You want to be able to get set up quickly and easily, then pack it up and move out without overexerting yourself. If you keep this in mind when acquiring your tools and materials, you will certainly enjoy plein air painting a lot more.

That keep-it-simple approach carries over to acrylic painting choices as well. Typically, acrylics have been used by plein air painters for quick studies or for a thin underpainting that can be worked over with oils later on. In this chapter we will explore acrylic painting strategies that allow for a wider range of paint manipulation when painting outdoors.

Building an Underpainting With Open Acrylics

This strategy uses slow-drying open acrylics to build up an underpainting that emphasizes value and structure in a warm monochrome, which can be as precise or as loose as you desire. The paint layers can take several hours to dry, so you may want to do a small series of works using this method and save them as underpaintings for a future session. Just make sure you return to the location at the same time of day. Transparent and opaque open acrylics can then be worked over your underpainting to great effect. (You already did all the hard work of composition, value, etc., on your first sitting!)

materials

surface | 8" × 10" (20cm × 25cm) Ampersand gesso board

open acrylics
Quinacridone/Nickel Azo Gold | Raw Umber
Titanium White

other | chisel-tipped Colour Shaper | folding metal easel | nylon wash brush | paper towels

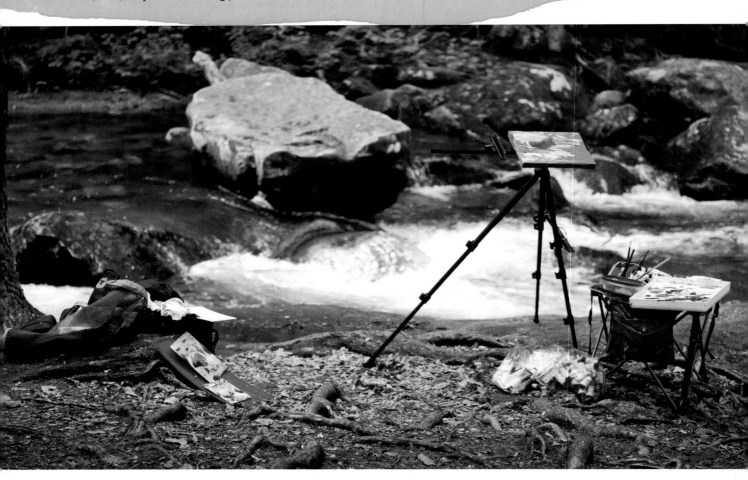

MY PLEIN AIR SET-UP

I use a lightweight metal folding easel with adjustable, telescoping legs, and set it up so that the canvas or panel is at a 45-degree angle. That angle makes it easier to do subtractive techniques. I also use a small folding table for easy access to my palettes, brushes, rags and water.

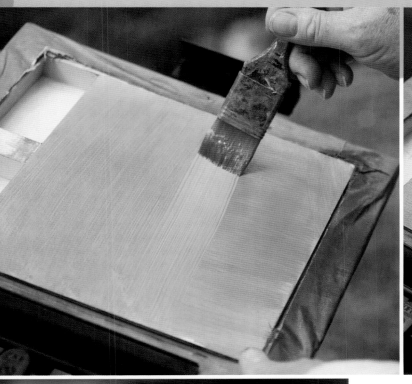

1 APPLY THE BASE LAYER

Use a nylon wash brush to apply an even layer of Quinacridone/Nickel Azo Gold to your surface. You want an even, smooth layer, but keep it thin enough that ridges of paint won't be pushed up when you draw into it. You also want a middle tone that you can work light or dark into later.

2 SMOOTH THE PAINT LAYER

Draw directly into the paint layer using a rubber-tipped Colour Shaper. (You could also use the end of a thin brush handle.) Keep your drawing loose initially—you just want to get a basic composition. Don't worry about making mistakes. Wet paint is very forgiving if you need to make corrections.

3 CONTINUE ADDING AND REMOVING PAINT TO COMPLETE THE UNDERPAINTING

Add Titanium White and Raw Umber to your palette and work in lights and darks as you desire. Use a dry brush or tightly-folded paper towel to model and remove paint as you go. One of the biggest benefits of using open acrylics is that it's easy to add and remove paint as you work.

You now have an underpainting that, once dry, can be overpainted with open or fluid acrylics, or even oils.

MEMENTO SALUDA

Phil Garrett | Acrylic on panel

10" × 10" (25cm × 25cm)

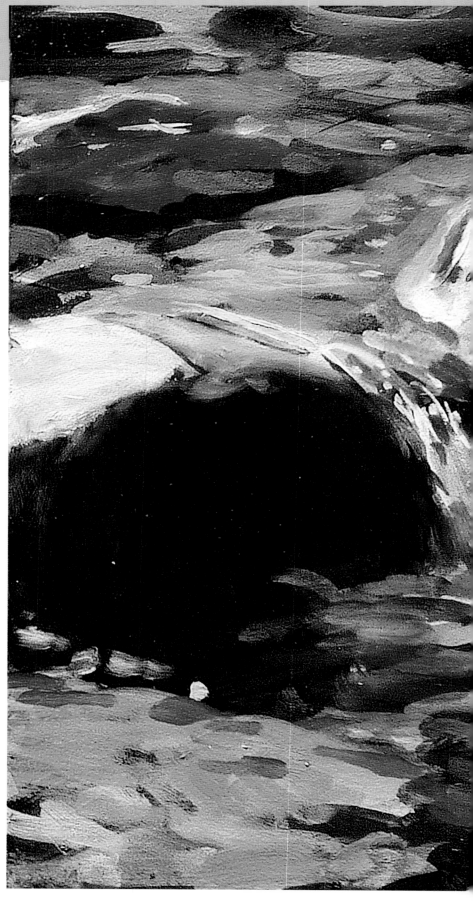

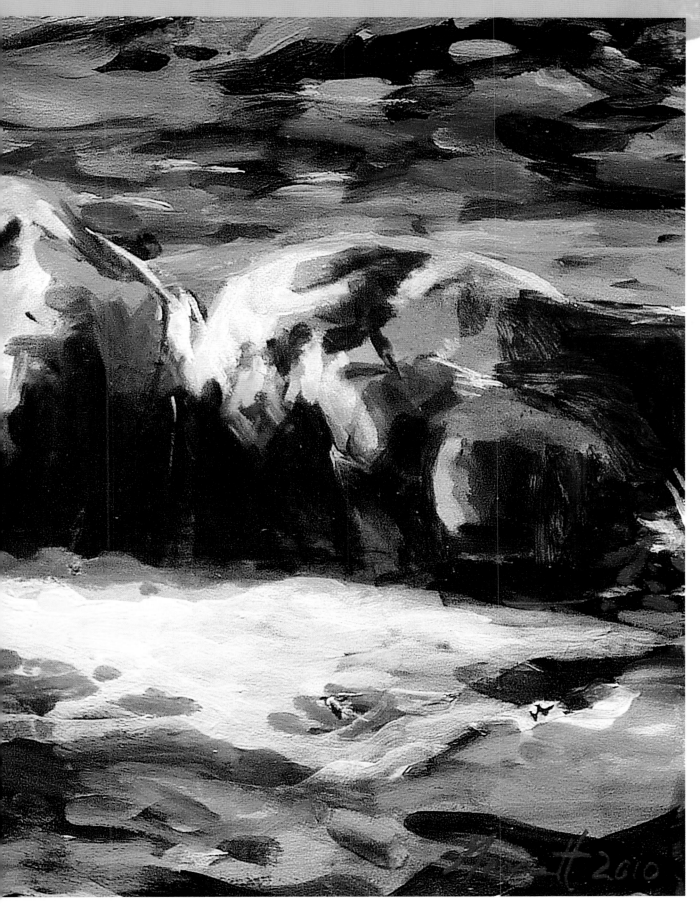

jim campbell's working process

Jim Campbell often uses the approach of working on a panel or canvas that has a medium-to-dark layer of dry paint over gesso as a beginning ground or imprimatura. This way, he has already established the medium tones and can simply add darks or lights as needed. Jim has used this technique to great effect over the years for everything from landscapes to portraiture, and even mixed media.

▲ Phil Garrett, Glen Miller and Jim Campbell on the Jones Gap Trail in South Carolina.

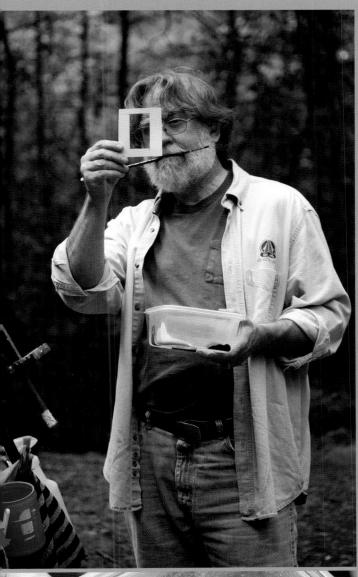

JIM ISOLATES HIS COMPOSITION

Jim uses a viewfinder to help isolate the basic elements of his composition before he starts painting. This is very useful when painting in a dense and visually busy landscape.

JIM'S PALETTE

Transparent color or glazing does not work very well for Jim's technique. Instead, he adds white to his colors so that they will be opaque and stand out against the dark ground of his painting. He leaves that dark ground unpainted for larger dark forms and patches of texture to enliven the surface of the painting.

Notice that Jim uses a common plastic storage container as his mixing palette—inexpensive and very practical for plein air painting with acrylics.

KEEPING THE PAINTS WORKABLE

Jim works with heavy body fluid acrylics. Because they are fast drying, he must keep the paint workable by periodically misting both his palette and the painting itself with water. He keeps a bottle mister clipped to the leg of his easel for easy access.

ACHIEVING THE DESIRED EFFECT

By using opaque color over the dark ground, Jim was able to achieve a true sense of the lush mountain-stream landscape and its deep colors.

RETREAT TO THE GAP

Jim Campbell
Acrylic on
wood panel
10" × 7"
(25cm × 18cm)

Visit artistsnetwork.com/insideacrylics to download free desktop wallpapers.

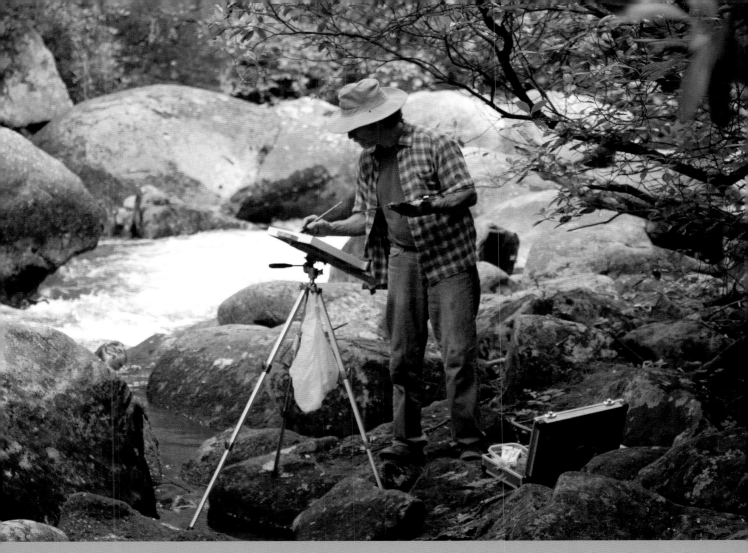

glen miller's working process

Glen Miller uses a tempered glass palette juxtaposed over a white gessoed canvas or panel for acrylic painting in the field. Because he builds much of the color in his paintings in the early stages, he keeps most of his paints pure and not mixed. Later in the process, he can hold the clear palette over a darker or lighter area of the painting to check his color mix.

Glen usually starts a plein air painting with only one color on his palette—either Ultramarine Blue or Raw Sienna—determined by the warmth or coolness of the shapes he's blocking in. He keeps the paint thin and transparent by adding acrylic medium in a mixture of gloss or matte that relates to the natural sheen of the paint used. Glen establishes his value areas quickly, leaving the brightest areas white. He then lays in the bold warm areas of a painting before moving on to the cooler areas. Much of these initial layers will be altered by eventual layers and glazes, so he is not overly concerned with the accuracy of his marks or the intensity or saturation of his colors early on.

▲ Glen Miller painting on the headwaters of the Saluda River, Jones Gap, South Carolina.

87

WORKING IN WARM PURE COLOR

Glen adds cool colors to his palette one at a time. He likes to work with warm and cool pairings, so these are worked through the painting and mixed with medium as needed, neutralizing shadow areas and adding touches of pure color.

WORKING IN OPAQUE COLOR

Glen adds touches of opaque color as well as more complex color mixes. Throughout this process he uses medium to modify transparency and paint consistency to areas of the painting that have become overly saturated. Finally, touches of opaque mixes are added to the lightest and darkest areas to achieve the desired color contrast. Within two hours the light had changed, and the painting was finished.

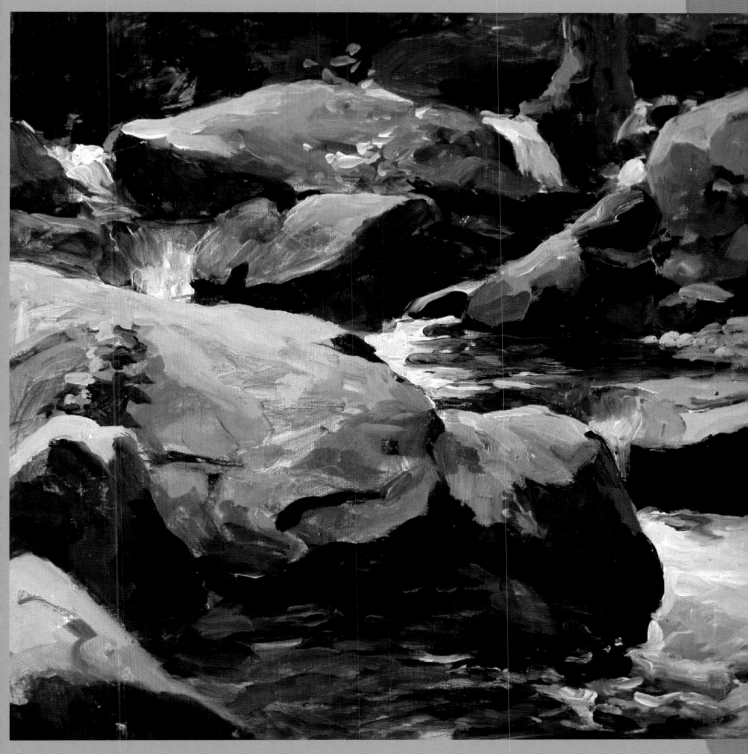

JONES GAP II

Glen Miller | Acrylic on canvas | 10" × 10" (25cm × 25cm)

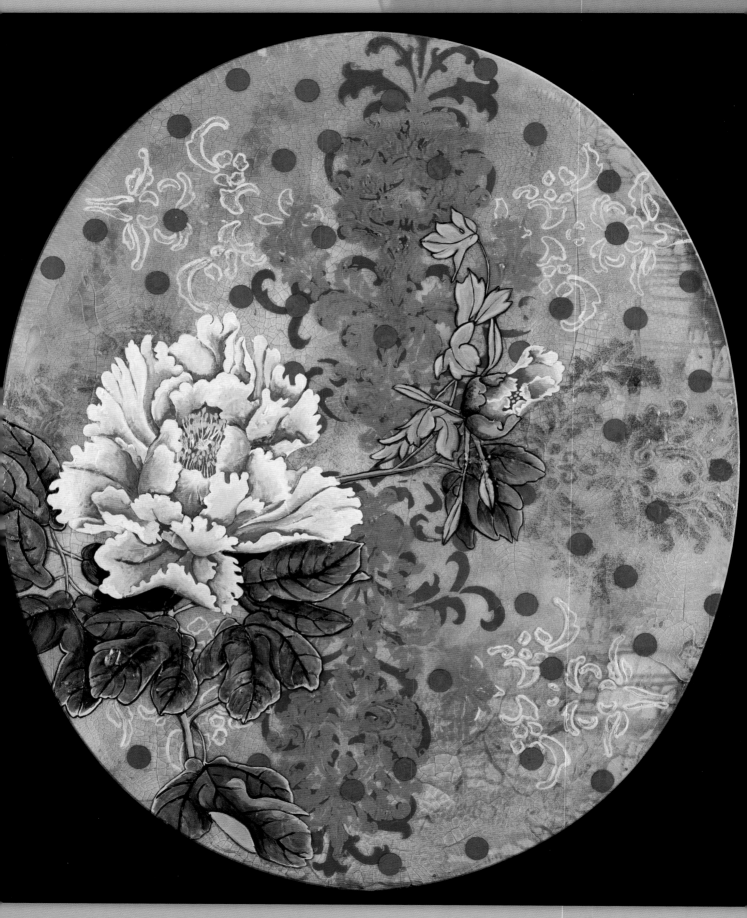

mixed media

Modern acrylic paints are well suited for experimental applications and pushing the limits in mixed media. This is largely because the binder in acrylic paints, gels and mediums can be flexible, stiff, clear, translucent, opaque, matte, gloss, thick, thin, smooth, textured, hard, soft, light or heavy. The options are truly endless and could fill several books quite easily. So far, this book has focused on mainly traditional acrylic techniques, but this chapter will introduce you to some of the more innovative options for acrylic painters.

PINK PEONY OR MY FIRST TAT

Patti Brady | Acrylic and acrylic collage on oval panel | 36" × 24" (91cm × 61cm)

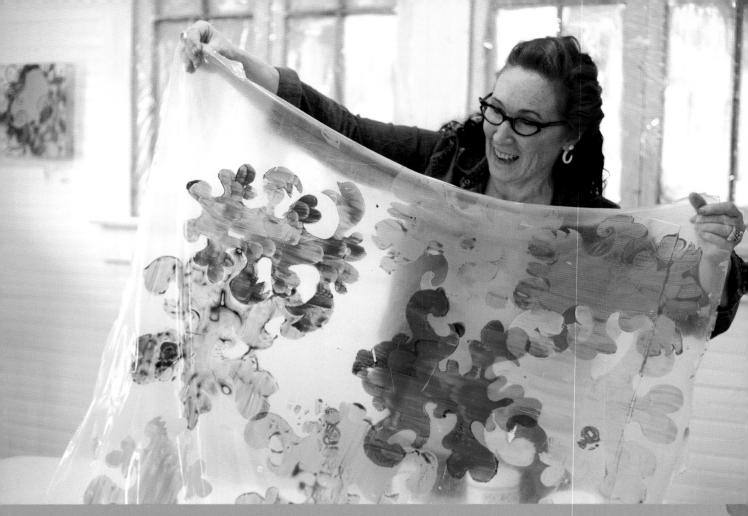

patti brady's working process

Patti Brady is the director of the Working Artist Program at Golden Artist Colors, Inc., as well as an author, lecturer, teacher and painter who is constantly pushing the boundaries of paint application. Specifically, she has focused on the education of artists in the use of acrylic. She creates challenges for herself by pushing beyond the limits of her knowledge with the materials. One of the ploys she has used is reinventing the concept of collage. The majority of her work is centered around the idea of putting disparate pieces together. Long ago, she began making collages with only acrylic, not the typical paper. That means she creates all of the "paper pieces" used in her collages from acrylic.

▲ Patti Brady at work on an acrylic skin.

ACRYLIC MIXED MEDIA TERMS

- **Pour**: Pouring fluid acrylic, mixtures of fluid acrylic and water, or mixtures of paint and various mediums
- **Acrylic skin**: The dried acrylic layer formed by making your pour on a surface that the acrylic will not bond with
- **Digital skin**: An acrylic skin that has been coated with digital ground and then printed on using an inkjet printer and digital image source

- **Acrylic collage**: Gluing acrylic skins and digital skins onto your painting as you would with paper elements
- **Stain**: Pouring mixtures of fluid acrylics highly thinned with water over absorbent layers of acrylic gels (light molding paste, fiber paste, coarse molding paste) or raw canvas, linen and watercolor paper

Making an Acrylic Skin

Acrylic can be made into a continuous film or "skin" that can be used as acrylic "paper." This is what Patti uses for her collages. Acrylic skins are easy to make. All you need is an acrylic product and a surface that the acrylic will not adhere to when it dries. Freezer paper, silicone baking sheets, plastic garbage bags, glass, and high-density polyethylene sheeting all work well for this.

Using one of those surfaces, apply any of the acrylic paints or gels (no crackle paste) in a contiguous layer, allow it to dry, then peel it off the surface. You can expand on this simple idea to make more unusual skins using different gels, or layers of paint and gels. Skins can be very thick, multi-layered, multi-colored, transparent, opaque or delicately thin.

The skin that Patti creates in this demonstration comes from her interest in several other aspects of acrylic exploration, coupled with her fascination with pattern.

materials

surface | large high-density polyethylene panel

fluid acrylics | assorted

brushes | wide synthetic brush

other | frosted mylar (or a stiff paper) | GAC 800 large palette knife | pencil | masking tape | scissors

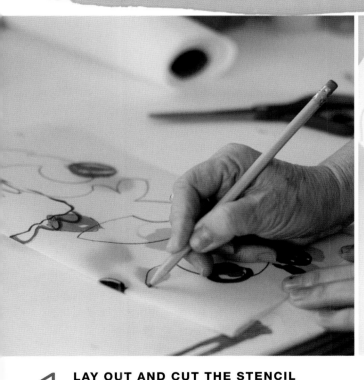
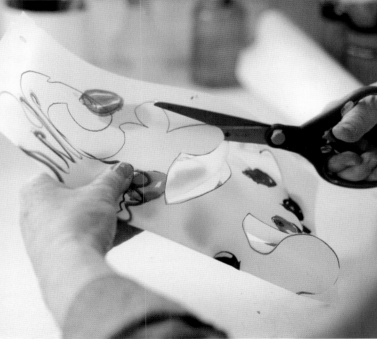

1 LAY OUT AND CUT THE STENCIL

Fold a piece of frosted mylar in half and begin a loose pencil outline of a Rorschach-like pattern. Cut out the shape. (Patti had a series of aborted drawings on frosted mylar in her studio from many years ago, and used one of those for the stencil. So don't be confused by the blue spots and the other pencil marks—they belong to the old drawing!)

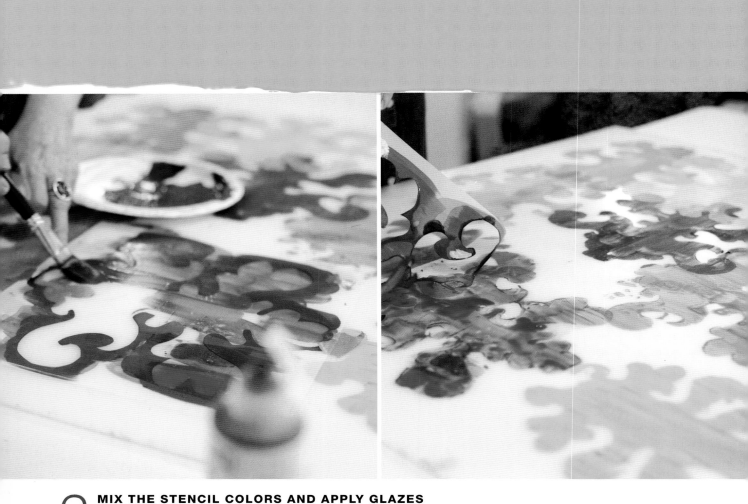

2 MIX THE STENCIL COLORS AND APPLY GLAZES

Fluid acrylics are especially good for any thin viscosities that you want to create. To make the washes, use combinations of fluid acrylics, polymer medium (gloss) and water. Get some transparency by thinning the brilliance of the fluid acrylics with the polymer medium. Add a large quantity of water to dilute the mixture even further. When using this over-thinned mixture, the application on the glossy surface of the high-density polyethylene (HDPE) panel produces an uneven surface. The paint actually crawls away, and often creates a series of spotted clusters of paint. This thin application will not create a skin, as there is simply not enough binder. (I thinned down the binder with too much water, specifically for the effect.)

Use a small piece of tape at the top of the stencil to adhere it to the HDPE panel. When the stencil is secure, paint a glaze over the stencil with a wide soft brush. Paint will typically seep under the edges. This is fine if you are not looking for clean tight edges. (I prefer the painterly application.) Pull off the stencil while the glaze is still wet. Continue to apply multiple layers of stencils, overlapping with earlier dry applications.

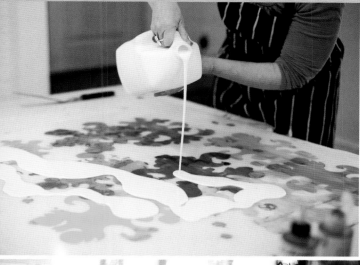

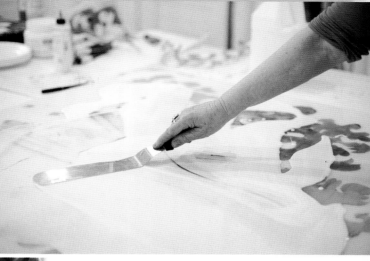

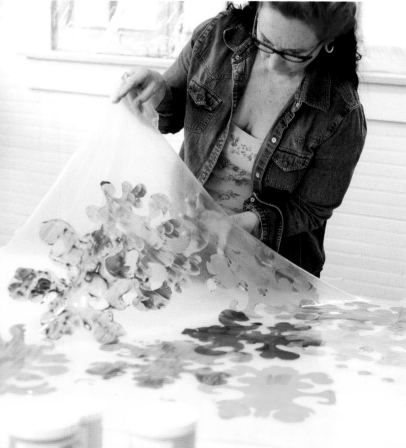

3 APPLY THE GAC 800

After all the stencil shapes on the HDPE panel have dried, pour GAC 800 over the entire surface. Use a palette knife to spread the GAC 800 evenly over the entire stenciled area on the HDPE panel. Leave it to dry for several days.

4 PULL UP THE SKIN

Once everything is dry, slowly and carefully peel the skin off of the HDPE panel. When doing this, check the edges to make sure they are thick enough to avoid tearing while removing. You can always add another layer of the GAC 800 if you determine that you need to make it a bit thicker. Letting it dry for several days will also lower the tack of the surface. Be very careful when removing the skin to keep it from folding back on itself. Fresh skins easily stick together.

WHAT TO DO WITH THE SKIN?

There are many options for using acrylic skins. A skin can be adhered to a larger panel as is, or cut into shapes and smaller pieces. It can be applied over a surface that is already painted. It can be painted on top of, or sandwiched between other skins. The options are endless—simply use a clean gel to adhere. My choice is soft gel gloss.

Combining Layers

Now let's follow along as Patti Brady takes us through the process for exploiting the possibilities of a range of paint and gels.

materials

surface | wooden panel

fluid acrylics | Indian Yellow Hue | Pyrrole Orange
Titanium Pink | Titanium White | Turquois (Phthalo)
Ultramarine Blue

gels and mediums | clear tar gel | gesso
heavy gel matte | open gel | polymer medium

brushes | wide soft brush

other | carbon paper | Colour Shaper
crackle paste | drawing for transfer

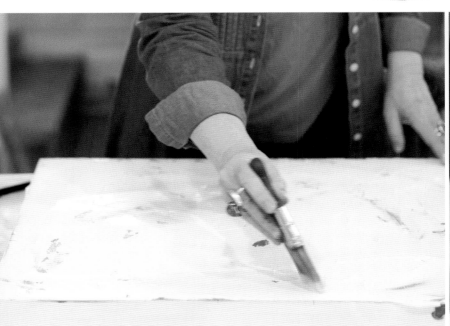

1 PREP THE PANEL

Apply two coats of polymer medium, and then a quick coat of gesso. Since you'll be working with textured gels, smooth surface application is not necessary. Create a toned ground on top of the gesso. (For this painting Patti used Turquois [Phthalo] mixed with Titanium White.) Once dry, apply a thick coat of crackle paste. Allow that to dry overnight. Thinner applications will provide smaller cracks and thicker applications will create larger cracks. When the crackle paste is completely dry, dampen it with clean water. Use a wide soft brush and make sure you saturate the entire surface.

2 POUR THE WASH AND GLAZE

Make a wash of Indian Yellow Hue mixed with a high proportion of water. Pour it directly onto the wet crackle paste. The wash will bleed into the cracks of the crackle paste, increasing their visibility. Allow it to dry.

CHOOSE THE SURFACE THAT BEST FITS YOUR NEEDS

Patti Brady always works on wooden panels because canvas is not a good surface for pouring or for crackle paste. The rigid wood panel surface also allows her to apply as many layers as she likes, and she can change direction at any time.

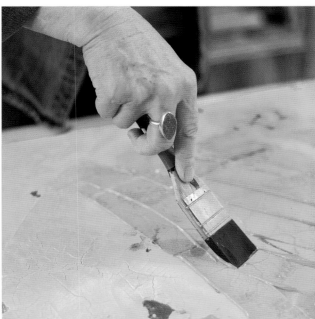

3 ADD ANOTHER ELEMENT OF GLAZE AND COLOR

Mix heavy gel matte with transparent Pyrrole Orange. Spread the gel mixture over the entire surface and use a Colour Shaper to "grout" the cracks of the crackle paste. Fill up all the crevices so that you will eventually have a smoother surface to paint on. The additional color will enhance the surface of the crackle.

When that coat is dry, pour and spread a layer of clear tar gel over the entire surface. You want a very smooth, glass-like gloss surface for the next step. Clear tar gel has a wonderful leveling quality, so it can somewhat even out a very textured surface.

4 TRANSFER THE IMAGE AND ADD ADDITIONAL SHAPES

Once the clear tar gel layer is dry, use carbon paper and a drawing of an image you've chosen to transfer shapes onto the surface. Place your main image first, then you can figure out where to place additional shapes and images.

Patti added some polka dots with Ultramarine Blue. The beautiful matte finish contrasts with the high gloss of the clear tar gel. To create the perfect surface for the traditional blending techniques that the peony required, a very white opaque and toothy surface was needed, so Titanium White was used for the peony underpainting.

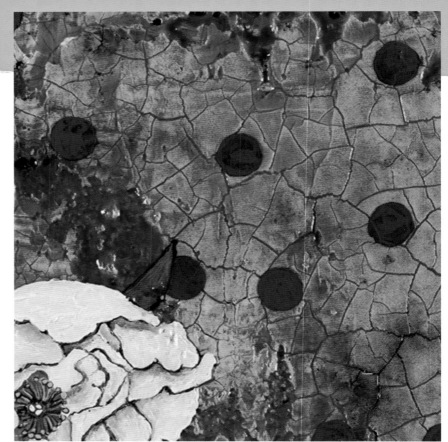

5 BLEND THE LIGHTS AND DARKS

When blending out the lights to darks, use open gel so that you can take your time. The matte surface of the fluid paints in the previous layers provides the perfect tooth for working with the "slippery" open gel. Because Patti was working on a very small surface, she didn't need the full open time, so she mixed the open gel with heavy body gel matte in the same pigments. That way she was able to choose a drying time appropriate to the size and technique she was working with. When mixing heavy body and open gels at a 1:1 ratio, typically, it can be glazed over the following day.

Begin by laying in the dark areas first, then going back and adding the lighter values. For blending the pink peony, several values of Titanium Pink were created, and each petal was blended individually.

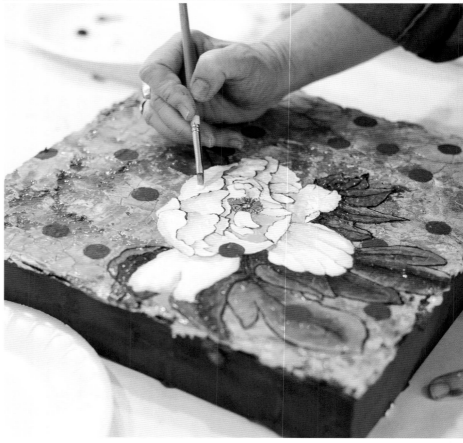

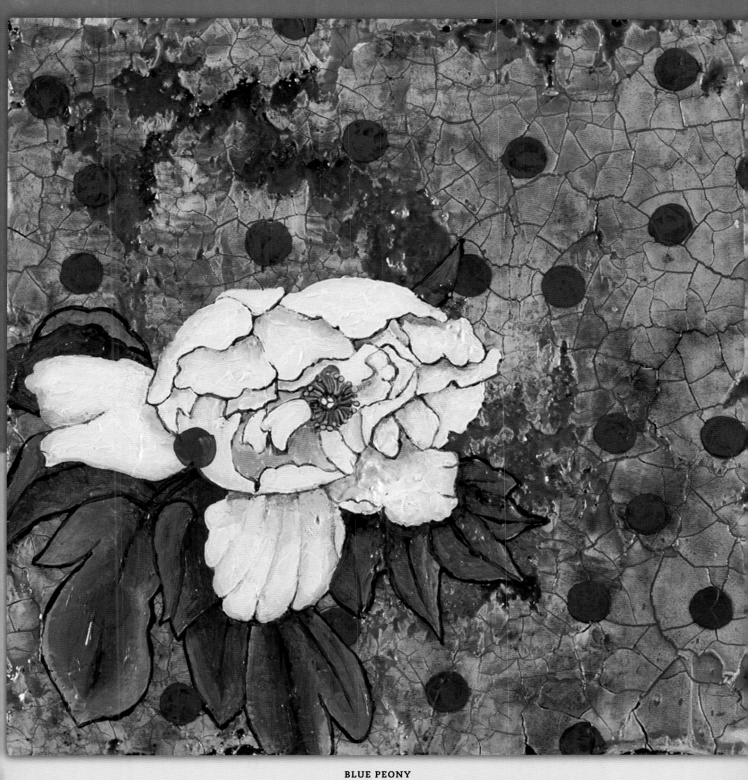

BLUE PEONY
Patti Brady | Acrylic mixed media on wooden panel | 12" × 12" (30cm × 30cm)

Making a Digital Acrylic Skin

Patti Brady took you through the process of making an acrylic skin using a more painterly approach, with stencils and brilliant paint color. Now I'll show you how to create a digital skin (a skin that is printed on with an inkjet printer) and incorporate it into a painting.

Digital skins can be either transparent or opaque, but they do need to be fairly neutral. I tend to layer open acrylics over them to complete a painting.

materials

surface | hardboard panel

grounds, gels & mediums | acrylic ground for pastels digital ground for non-porous surfaces fluid iridescents | fluid interferences GAC 100 | GAC 800 | soft gel gloss

other | 3-inch (26mm) foam brush archival spray varnish with UVLS | blue painter's tape | freezer paper or cover stock paper high-density polyethylene panel | inkjet printer mat knife | rubber brayer | steel palette knife

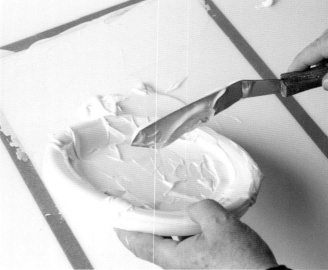

1 MIX YOUR FORMULA

My basic formula for digital skins is 2 parts soft gel gloss to 1 part acrylic ground for pastels. If I want it thinner, I might add 10 to 20 percent of GAC 100 or GAC 800. I sometimes add 10 to 15 percent of a fluid iridescent (reflective metallic paint) and 10 to 15 percent of a fluid interference color. (Fluid interference paints show both the color and its complement when viewed from a different perspective.) The addition of acrylic ground for pastels gives the skin some tooth, which is useful for drawing on, and also a translucent matte surface.

2 APPLY THE MIXTURE TO THE PANEL

On a high-density polyethylene HDPE panel, lay out a three-sided rectangle of blue painter's tape. Use a steel palette knife to spread an even layer of the skin mixture. Start in the center and work out towards the edges, allowing the mixture to cover the inner edges of the tape. Let this dry and cure for twenty-four to forty-eight hours. Once dry, coat the cured skin with two consecutive layers of digital ground for non-porous surfaces using a clean dry foam brush. Allow it to dry between coats.

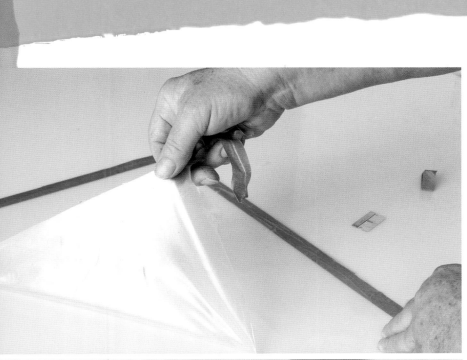

3 PULL UP THE SKIN

When the skin is dry, cut along the inside edge of the tape with a mat knife, then carefully pull up the cured and coated skin. Go slowly to avoid tearing.

4 PRINT AND SEAL THE IMAGE ONTO THE SKIN

Tape the skin to the coated side of a carrier sheet and load it into your inkjet printer. Freezer paper cut to size or standard cover stock paper with its stiff backing both work very well as carrier sheets.

It's best to use a computer for your image source because this will offer more options for manipulating the image. You can also use the copy setting for copying directly from small drawings and paintings. I print to a standard inkjet printer with an L-shaped feed, but inkjet printers with straight-through feeds will work also.

Seal the printed skin with a solvent-based acrylic sealer. (I use a gloss archival spray varnish with UVLS.) Don't use a water-based sealer as this could cause the image to bleed and lift. Spray on several coats and let the skin dry completely before you handle it. Don't forget to wear a respirator and eye protection, and only spray in a well ventilated area.

5 ADHERE THE SKIN TO THE PANEL

Apply the skin to a sealed and gesso-coated hardboard panel. Use soft gel gloss as adhesive. Work any trapped air bubbles out towards the edges of the skin using a rubber brayer. Repeat this process for as many skins as you wish to add to the panel. Then place the panel face down on a sheet of freezer paper on a level surface under even weight. Leave it to sit overnight.

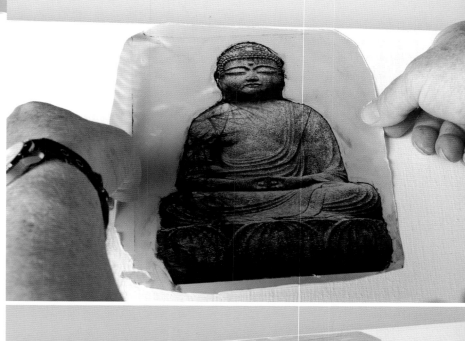

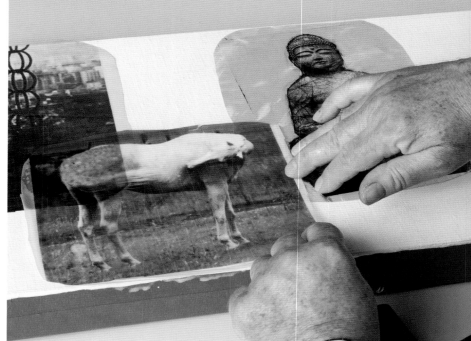

6 CONTINUE BUILDING PAINT AND COLLAGE LAYERS

Work and blend layers of open acrylic paints over the panel. At this point, you can add more digital skins and other collage elements, continue to build up textures and paint layers… whatever you wish to do.

MEMENTOS OF NIKKO AND KYOTO

Phil Garrett | Acrylic and digital mixed media on hardboard panel | 10" × 30" (25cm × 76cm)

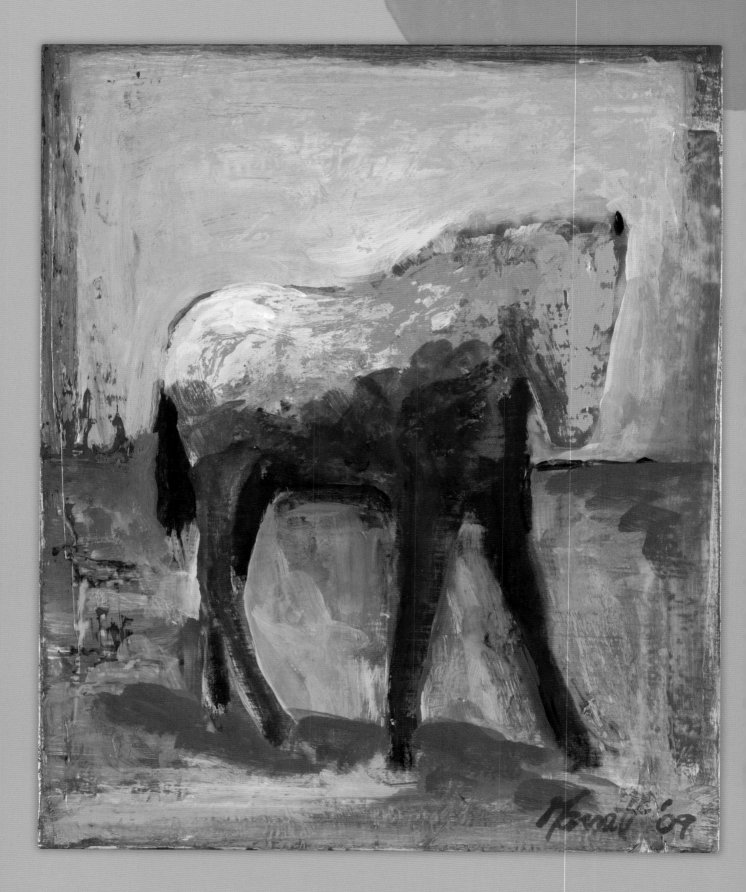

varnishing

Putting a varnish on your finished (completely dry and cured) acrylic painting is a way to protect that surface for many years to come. A correctly chosen and applied final varnish with UV light filters can add to both the longevity of your painting and the success of your aesthetic. One of the main purposes of this book is to show how you can use acrylics yet still achieve the richness and vibrancy associated with oil paints. I have found that my choice of varnish and the manner in which I apply it can contribute to that rich and vibrant quality.

BISCHOFF'S COLT
Phil Garrett | Acrylic on canvas | 10" × 8" (25cm × 20cm)

varnishing basics

Acrylic binder can soften or harden, depending on the temperature of its immediate environment. So, if your finished and dry painting is hanging on the wall in a room that is not air conditioned on a hot summer day, and dust blows in through an open window, those dust particles can become embedded on your painting's warm softened surface. Over the years, this can alter and affect a painting's surface. What's more, there is no way to rectify this without damaging the paint film. It may sound like a worst-case scenario, but think about the average build-up of dust and hair that can accumulate in a given space over a couple weeks. All of these particles build up over time and can embed into the acrylic paint film unless a varnish is applied to prevent this from happening. A final varnish can also serve to unify the surface of the finished painting in an aesthetic way by muting normally glossy surfaces or shining up matte ones.

The final varnish must be a removable protective layer. Putting a coat of polymer medium over a finished painting is not a final varnish because the polymer medium becomes part of the paint film and is not removable without harming the paint layer. The varnish I have used for many years is Golden MSA (Mineral Spirit Acrylic) Varnish with UVLS. I like the clarity, durability, flexibility, lack of tack, sheen, and (to my eye) enhanced saturation of color that I get with the MSA. The MSA varnish is thinned with mineral spirits solvent and can be removed with the same mineral spirits solvent.

Due to health issues surrounding the use of solvents, I wear nitrile gloves, a respirator and eye protection while varnishing. I varnish multiple paintings at the same time, then leave the studio until the next layers can be applied. In other words, I minimize my exposure to the solvent and curing varnish as much as possible. If you would simply rather not work with solvents, or if you have health issues that preclude their use, I recommend Golden Polymer Varnish with UVLS. This varnish is thinned with water and removable with ammonia spirits.

TO VARNISH OR NOT TO VARNISH?

Before varnishing an acrylic painting, it is important to consider how the unifying sheen of a final varnish affects your painting's overall surface aesthetic. If you purposely have glossy areas next to matte or heavily textured areas of paint or collage, and that variety of surface and sheen is key to what you want to say in the painting, then forgoing the varnish layer may be a better aesthetic choice. As the artist, only you can make that decision.

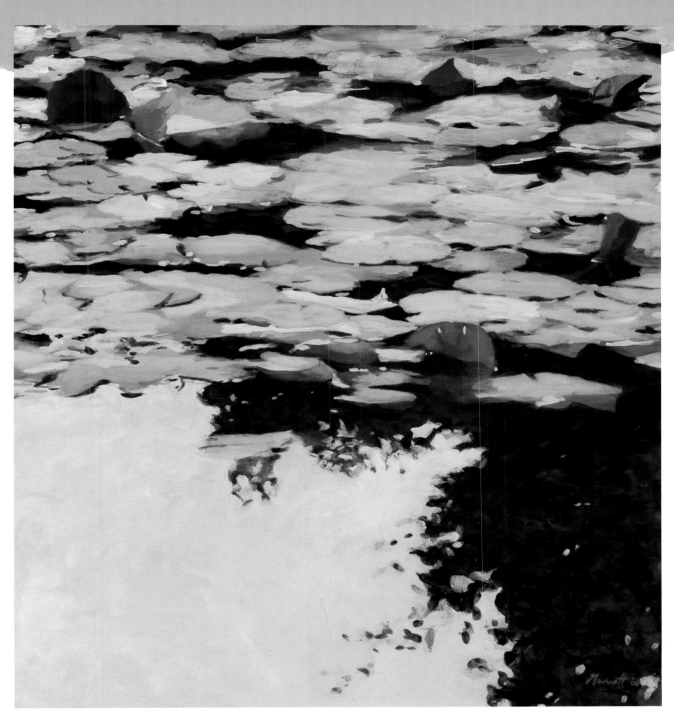

THE FINAL VARNISH EFFECT

An example of a painting that is enhanced and protected by a
final varnish.

MEMENTO/ LAKE AT RYOANJI IV

Phil Garrett | Acrylic on panel

36" × 36" (91cm × 91cm)

DEMONSTRATION
Applying a Final Varnish

You have decided that your acrylic painting needs a final varnish. Before you forge ahead, I suggest you practice the techniques I have outlined in this demonstration on a test painting first. There is a skill level involved in getting a good final varnish; it takes some practice to get it just right. Take your time, follow the steps, and you'll get there.

materials

brushes | 3-inch (76mm) synthetic flat

gels and solvents | MSA varnish
soft gel gloss | mineral spirits solvent

other | 1 foot (30cm) of a ⅜-inch (10mm) dowel stick
glass containers with airtight lids | eye protection
foam plate | measuring glass | nitrile gloves
rags | respirator mask

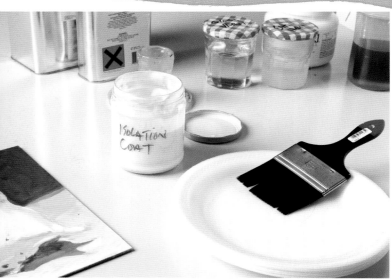

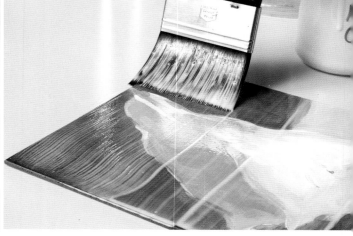

1 MIX THE ISOLATION COAT
The isolation coat is a mixture of soft gel gloss and 20 to 40 percent water. Stir and then let it sit for twenty-four hours before using.

2 APPLY THE ISOLATION COAT
Pour the mixed isolation coat onto a plastic foam plate. It should be about the consistency of heavy cream. Load a wide synthetic flat brush with the isolation coat. (Like all acrylic binder, it's white when wet but will dry clear.) Brush the isolation coat onto the painting in even and parallel strokes. This mixture levels pretty well and the streaks will disappear as it dries. Watch the build-up on the edge of your strokes. If you choose to apply a second layer of isolation coat, wait for the first layer to dry and then apply the second layer at a 90-degree angle to the first layer. Allow one day for the isolation coat to thoroughly dry before applying the final varnish.

BEFORE VARNISHING...

1. Give your painting time to dry or cure. Wait one to three weeks for paintings done with fluid and/or heavy body acrylics and gel mixtures. Open acrylics need to dry for thirty days.
2. Clean the entire surface of the dry painting with water and a lint-free cloth in a gentle manner. Leave it to dry for a day. There are surfactants that work themselves into the surface of a cured painting and form a very thin soapy film. A gentle cleaning will remove this.
3. It's recommended to apply an isolation coat (not removable) to seal, level and add a protective layer to the paint film before applying the final varnish. Allow one day for this to dry.

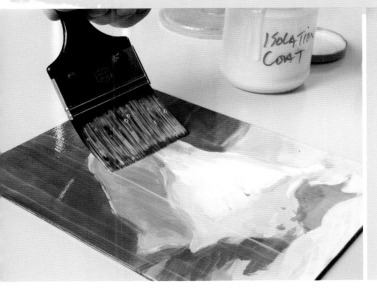

3 PREP YOUR BRUSHES

While the isolation coat is drying, soak the brushes that you plan to use for applying the MSA varnish in a container of mineral spirits solvent. This makes clean-up easy later on.

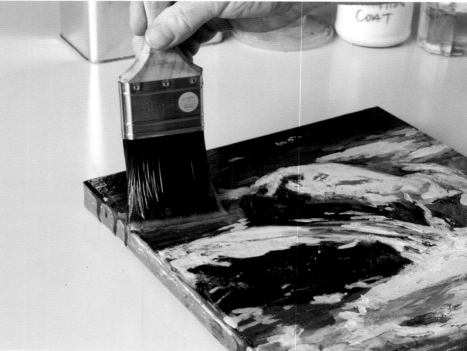

4 MIX THE GLOSS VARNISH

In a glass container, mix 3 parts MSA varnish to 1 part mineral spirits solvent and stir with a dowel stick. The mixture will appear cloudy initially and then become clear as you stir. If the mixture doesn't clear as you stir, then the solvent is not a pure mineral spirit—discard and use a pure mineral spirit.

5 APPLY THE GLOSS VARNISH

Wipe any excess solvent off the flat wide brush and then use it to apply the first of two layers of gloss varnish. Parallel strokes are best. (Side lighting will help you to see if you've missed overlapping your strokes.) Leave it to dry for at least four to five hours. It should be dry to the touch, not sticky. Apply the second coat at a 90-degree angle to the first coat. Let this second coat dry overnight before applying your final coat of satin varnish.

6 MIX AND APPLY THE FINAL SATIN VARNISH

Mix 1 part mineral spirits solvent to 3 parts MSA varnish to create the final satin varnish. Apply the satin varnish in parallel strokes with a flat wide brush. Stir the satin varnish several times as you apply it to keep the matting agent consistent throughout the mixture.

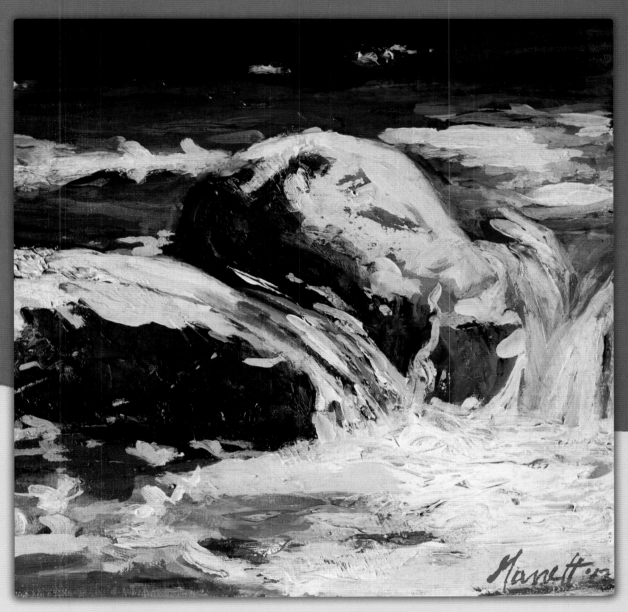

KEEP IT LOOKING FRESH AND CLEAN

This painting has an isolation coat followed by two coats of gloss MSA varnish and a final coat of satin MSA varnish. It has a soft sheen that makes the paint look as wet and fresh as the day it was painted.

MEMENTO/RED ROCKS

Phil Garrett | Acrylic on linen applied to wood panel

12" × 12" (30cm × 30cm)

Removing a Varnish

Removing a varnish is not a task to be taken lightly. It sometimes needs to be done, however, if a painting is damaged and needs repair. On occasion I have felt the need to rework a painting that I just wasn't satisfied with. To do that correctly, the varnish had to be removed. I wouldn't attempt to remove a varnish from a painting that I didn't execute myself. That is definitely a job for a trained conservator of paintings. The technique I will show you is specifically for removing a mineral spirits-based acrylic varnish from an acrylic painting that has been painted on a sealed and primed canvas, stretched linen, wood or hardboard panel, or linen or canvas applied to a panel.

materials

cotton rags | empty can and funnel
eye protection | mineral spirits solvent
nitrile gloves | respirator

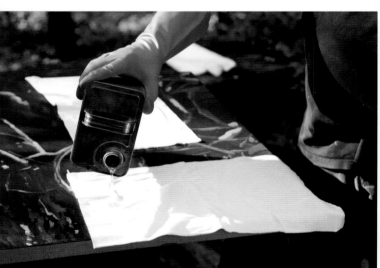
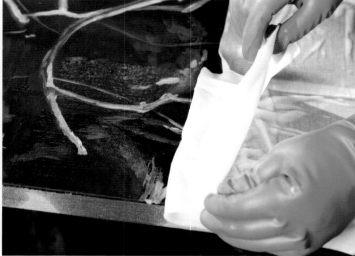

1 APPLY COTTON RAGS AND SATURATE WITH SOLVENT

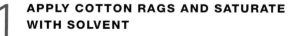

Rest the painting on saw horses or a work table in a well ventilated area. Lay cotton rags out on the painting in sections and pour mineral spirits solvent onto the rags. After thoroughly saturating the rags with the mineral spirits, leave them sit 10 to 15 minutes for the varnish to dissolve.

2 REMOVE THE RAGS AND REPEAT THE PROCESS

Pull up the rags and squeeze out the excess solvent and removed varnish into a safe container. Reapply and re-saturate the rags. Repeat the process across the painting until all varnish is removed. It may take several applications and removals of the saturated rags to lift all the varnish. Be patient; this process can take up to several hours for a large painting with multiple layers of varnish. After all the mineral spirits solvent has evaporated from the surface of the painting, give it a gentle clean with a lint-free rag and water.

REWORKED PAINTING WITH VARNISH REMOVED

I removed the varnish and re-worked this painting on three separate occasions over a ten-year period. I think I am finally finished with it. Maybe.

COLT

Phil Garrett | Acrylic on canvas

36" × 36" (91cm × 91cm)

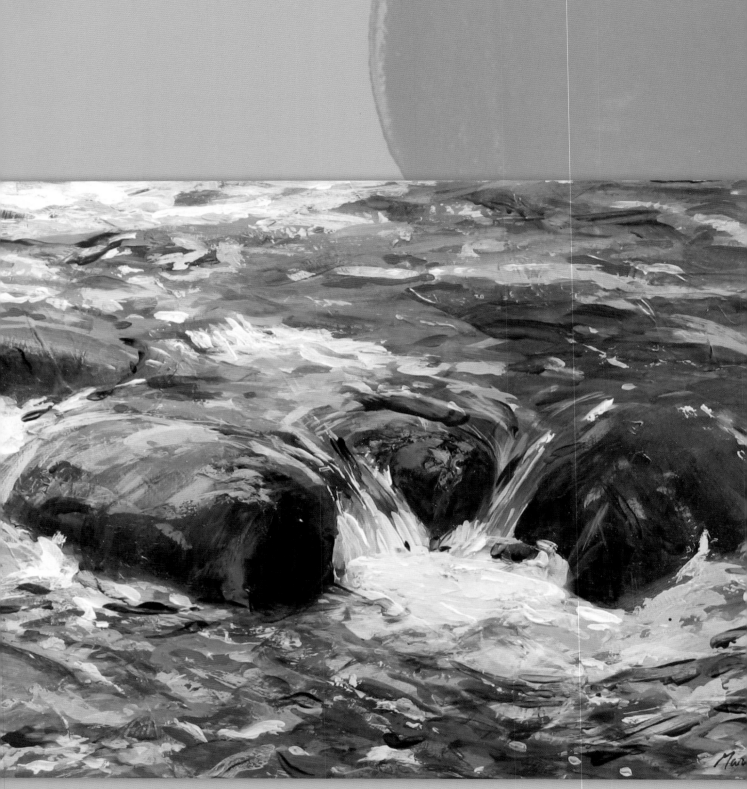

COOL POOL

Phil Garrett | Acrylic on panel | 10" × 12" (25cm × 30cm)

framing, shipping and storage

In this final chapter I want to share some ideas about how to present your work in a straightforward and professional way so that your finished work is enhanced but not overshadowed by framing. I'll also show you some simple options for storage that will protect your paintings for years to come. Last but not least, we'll cover how to handle, pack and ship your finished acrylic paintings.

framing options

There are enumerable options for framing paintings on canvas or panel. One consideration that can inform your choice is the depth of the panel or canvas. If you use a standard frame with a rabbet depth of ¼ inch (6mm) and your panel is 1½ or 2 inches deep (38mm-51mm), a lot of the panel will be sticking out the back of the frame. If the face of the frame is narrow, it's possible to see the back edge of the canvas or panel.

One solution is to use a frame with a 2½-inch (64mm) or even wider face so that the back isn't as noticeable. My preferred solution is to use what is called a floater frame. The floater is deeper than the canvas or panel and forms a channel that the canvas or panel fits inside. I prefer this option because it presents all of a painting's face without any of it covered by the frame.

Many contemporary painters use a basic hardwood floater with the idea that a simple frame protects and dresses up a painting without competing visually with it. Some painters attach a simple wooden lath strip or a finished hardwood strip to the sides of the painting using wire brads or countersunk wood screws. If this is done well it can look very good, but if you aren't much of a woodworker, have a professional picture framer do it. I like to use a more upscale version of the floater frame. This frame has a metal leaf finish that has been antiqued and the inside of the frame is a flat black or brown. It combines a classic style with a contemporary presentation. This can cost more to use, but it has an elegant look.

HARDWOOD FLOATER FRAME
The floater-type frame doesn't cover the face of the painting, though it protects the sides and edges.

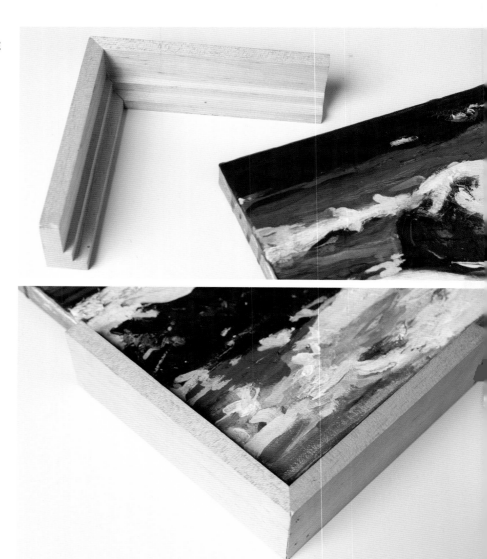

ENCOUNTER VARIATION
Phil Garrett | Acrylic on linen applied to panel
36" × 48" (91cm × 122cm)

CORNER DETAIL OF FLOATER FRAME

The dark stain on the inside accents the edge of the painting. To achieve a floater frame effect, mount a painted or stained wood strip (slightly wider than the depth of a traditional frame's rabbet) to the side of the painting, then attach the frame to the wood strip. This can give you more options for the outside, finished frame.

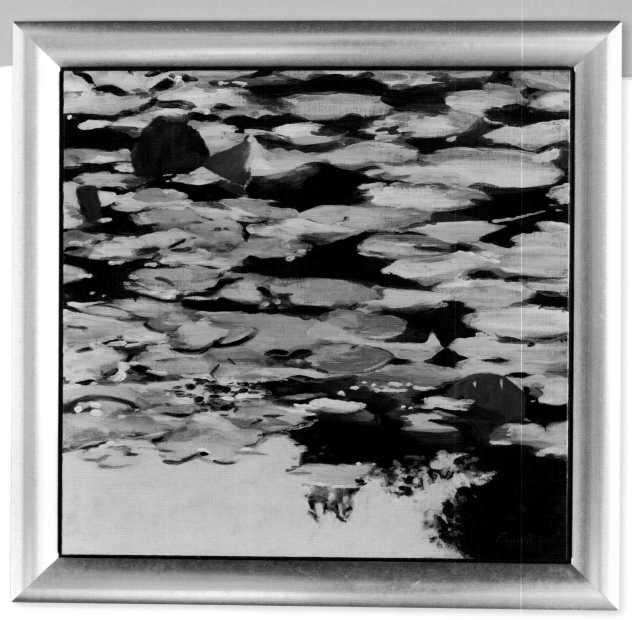

MEMENTO/LAKE AT RYOANJI IV
Phil Garrett | Acrylic on linen applied to panel
36" × 36" (91cm × 91cm)

CORNER DETAIL OF FRAME

The standard frame over the painted wood strip creates a floater effect. Sometimes using a wider gold or silver leaf frame over a stained wood strip attached to the side of a small but dynamic painting gives the feeling of a larger painting.

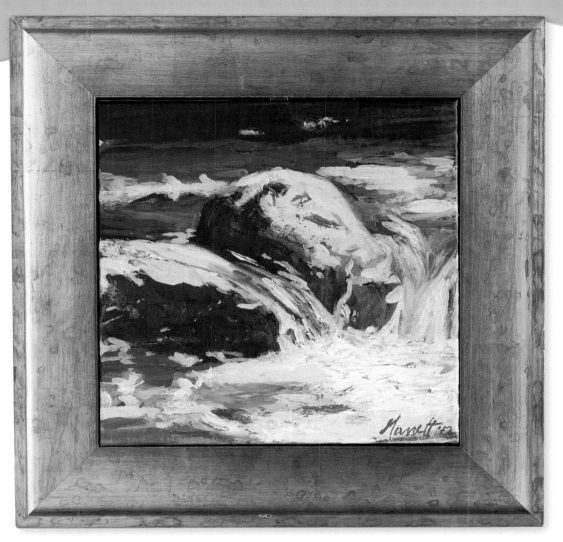

MEMENTO/RED ROCKS

Phil Garrett

Acrylic on linen applied to wood panel

12" × 12" (30cm × 30cm)

CORNER DETAIL OF FRAME

The two basic framing options for acrylic paintings on paper that I use consistently are the standard window mat glass and frame, and a type of float mount that uses a deep spacer strip between the mount and the glazing. As with framing any works on paper, you want to use archival (acid-free) mat board or foam core for matting and mounts.

An acrylic painting on paper with a typical window mat, glass and cap style frame.

Work on paper float mounted with ⅜-inch (10mm) spacer between mount and glass. Framed with a black cap-style frame.

shipping

Shipping an acrylic painting can be a somewhat stressful affair. Most damage to acrylic paintings during shipping happens because something came in contact with the surface. This can cause a range of damage from ferrotyping (a transfer of texture or sheen alteration), paper or packing items sticking to the surface, cracking due to a sharp impact at temperatures under 45° Fahrenheit, or when a not-quite-dry painting receives a gentle blow. Reduce the risk of your artwork being damaged in shipping by making informed choices about how you protect, box or crate your painting.

First, give your painting ample time to cure—several weeks for a varnished painting done with heavy body or fluid acrylics, and at least a month for a varnished painting done with open acrylics and mediums. It is best to have an airspace of about half an inch between the painting's surface and the shipping crate. I stand strips of heavy corrugated cardboard or foam core around the sides of the painting and rest a heavy sheet of corrugated board on top to provide that protective airspace. Then it's ready to be crated or boxed.

For larger paintings, I usually build a crate or if my budget allows, use an art-moving service. For more standard-size and smaller works, I have had great results using an Airfloat Systems product called StrongBox. This is a lightweight but strong double corrugated box with two outer layers of convoluted foam padding and a center layer of foam that is perforated and can be custom sized to fit the painting. These can be re-used a number of times.

DIAGRAM OF A SHIPPING CRATE

Courtesy of Golden Artist Colors, Inc.
Just Paint, issue 11

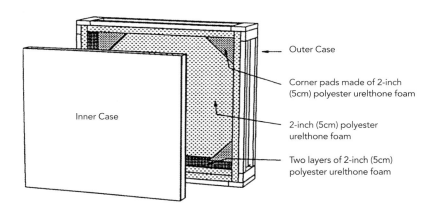

Inner Case

Outer Case

Corner pads made of 2-inch (5cm) polyester urelthone foam

2-inch (5cm) polyester urelthone foam

Two layers of 2-inch (5cm) polyester urelthone foam

STRONGBOX

Courtesy of Airfloat Systems, Inc.

TIP

Don't ever wrap an unprotected acrylic painting in bubble wrap. It's possible it will reach its destination with circular marks on the surface.

storage

The issues around storing acrylic paintings are similar to those of packing and shipping. Your painting needs to be dry and cured thoroughly, and you want to avoid prolonged pressure and contact with the surface of the painting. Again, I strongly urge you not to wrap and store your acrylic paintings in bubble wrap. If you have to wrap your paintings, use 4mm or thicker polyethylene clear or black smooth roll sheeting. Avoid folded plastic as well—the creases could ferrotype the painting's surface.

It's best to have a room or area in your studio or home that is dedicated solely to storage and can accommodate your paintings resting vertically. If it's in an attic or storeroom that is dusty, isolate the space with heavy plastic tacked to the outside of the storage rack to avoid dust and bugs from settling on the paintings.

PHILIP MULLEN'S LARGE STORAGE AREA

▶ STORAGE RACKS

These storage racks are solidly built with heavy plywood and 2" × 4" (5cm × 10cm) lumber. Large paintings are kept on the bottom and small paintings rest on top. My own storage is similar, except that I use sheets of corrugated cardboard larger than the paintings as dividers. I always make sure to leave some wiggle room between the paintings and am careful not to store them face-to-face.

index

METRIC CONVERSION CHART

To convert	to	multiply by
Inches	Centimeters	2.54
Centimeters	Inches	0.4
Feet	Centimeters	30.5
Centimeters	Feet	0.03
Yards	Meters	0.9
Meters	Yards	1.1

 Other fine North Light Books are available from your favorite bookstore, art supply store or online supplier. Visit our website at fwmedia.com.

17 16 15 14 13 5 4 3 2 1

DISTRIBUTED IN CANADA BY FRASER DIRECT
100 Armstrong Avenue
Georgetown, ON, Canada L7G 5S4
Tel: (905) 877-4411

DISTRIBUTED IN THE U.K. AND EUROPE
BY F&W MEDIA INTERNATIONAL
LTD Brunel House, Forde Close, Newton Abbot, TQ12 4PU, UK
Tel: (+44) 1626 323200, Fax: (+44) 1626 323319
Email: enquiries@fwmedia.com

DISTRIBUTED IN AUSTRALIA BY CAPRICORN LINK
P.O. Box 704, S. Windsor NSW, 2756 Australia
Tel: (02) 4560 1600, Fax: (02) 4577 5288
Email: books@capricornlink.com.au

ISBN: 978-1-4403-1703-3
SRN: W4548

Edited by Christina Richards
Designed by Wendy Dunning
Production coordinated by Mark Griffin

ABOUT THE AUTHOR

Phil Garrett grew up in South Carolina. He completed his undergraduate work at the University of South Carolina and the Honolulu Academy of Arts, where he studied printmaking under Gabor Peterdi. He received an MFA at the San Francisco Art Institute in 1974. His work is in numerous public and private collections nationally and internationally. He has completed numerous artists' residencies and taught acrylic painting and printmaking in the U.S., the European Union and Japan. He is the founder and master printer at King Snake Press, a print studio that prints and publishes monotypes by a select group of American artists. Visit his website at philgarrett.com.

Artist statement: My work is informed by nature. A kind of mythical nature—the power of storms, the spiritual quality of the elements, the beauty, grace and ferocity of plants and animals—something greater than myself, something I can't comprehend. Painting and making monotypes is my search for the mystery within the subject, within myself.

ACKNOWLEDGMENTS

Many thanks to Patti Brady, Mark Golden and all the wonderful folks at Golden Artist Colors, Inc., for freely sharing their knowledge and enthusiasm for acrylic painting. I couldn't begin to quantify their influence on my studio practice.

I want to especially thank Patti Brady, Jim Campbell, Glen Miller, Ed Rice, Mike Williams, Philip Mullen, Linda Fantuzzo and John Hull for sharing their wonderful work, expertise and valuable time. I couldn't have done this book without their generosity and support.

Thanks to Eli Warren for his insightful photography and love of cattle dogs.

Thanks to my editor, Christina Richards, for her sweet patience and good humor.

And last but not least, to my students—former and future. It is your openness and enthusiasm for painting that keeps me excited about teaching.

DEDICATION

To my loving family: Zelphia Louise Miller, Carey Elizabeth Garrett and David Robert Garrett.